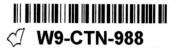

Creating **Textured** Landscapes

WITH PEN, INK AND WATERCOLOR

APPLE TREE IN SPRING GREEN
pen, ink and watercolor

Creating *Textured* LANDSCAPES

with *pen, ink* and *watercolor*

Claudia Nice

NORTH LIGHT BOOKS
CINCINNATI, OHIO
www.artistsnetwork.com

except by a reviewer who may quote brief passages in a review. Published by North Light Books, an imprint of F+W Media, Inc., 10151 Carver Road #200, Blue Ash, OH 45242. (800) 289-0963. First Paperback Edition 2012.

Other fine North Light Books are available from your local bookstore, art supply store or online supplier. Visit our website at **www.fwmedia.com.**

16 15 14 5 4 3

Distributed in Canada by Fraser Direct
100 Armstrong Avenue
Georgetown, ON, Canada L7G 5S4
Tel: (905) 877-4411

Distributed in the U.K. and Europe by David & Charles
Brunel House, Forde Close, Newton Abbot, Devon, TQ12 4PU, England
Tel: (+44) 1626 323200, Fax: (+44) 1626 323319
Email: enquiries@fwmedia.com

Distributed in Australia by Capricorn Link
P.O. Box 704, S. Windsor NSW, 2756 Australia
Tel: (02) 4577-3555

Library of Congress has cataloged hardcover edition as follows:
Nice, Claudia
 Creating textured landscapes with pen, ink and watercolor / Claudia Nice.
 p. cm.
 Includes index.
 ISBN-13: 978-1-58180-927-5 (hc : alk. paper)
 ISBN-10: 1-58180-927-1 (hc : alk. paper)
 1. Pen drawing--Technique. 2. Watercolor painting--Technique. 3. Texture
(Art)--Technique. 4. Landscape in art. I. Title.
NC905.N518 2008
751.4272436--dc22
 2007061232
ISBN: 978-1-4403-1856-6 (pbk : alk paper)

Edited by **Kathy Kipp**
Designed by **Jennifer Hoffman**
Photography by **Christine Polomsky**
Production coordinated by **Greg Nock**

About the Author

Claudia Nice is a native of the Pacific Northwest and a self-taught artist who developed her realistic art style by sketching from nature. She is a multi-media artist, but prefers pen, ink, and watercolor when working in the field. Claudia has been an art consultant and instructor for Koh-I-Noor/Rapidograph and Grumbacher. She is also a certified teacher in the Winsor & Newton Col Art organization and represents the United States as a member of the Advisory Panel for *The Society of All Artists* in Great Britain.

 Claudia travels internationally conducting workshops, seminars and demonstrations at schools, clubs, shops and trade shows. She has opened her own teaching studio, Brightwood Studio (*brightwoodstudio.com*) in the beautiful Cascade wilderness near Mt. Hood, Oregon. Her oils, watercolors, and ink drawings can be found in private collections across the continent and internationally.

 Claudia has authored twenty successful art instruction books, including more than twelve books and DVDs for North Light.

 When not involved with her art career, Claudia enjoys gardening, hiking and horseback riding in the wilderness behind her home on Mt. Hood.

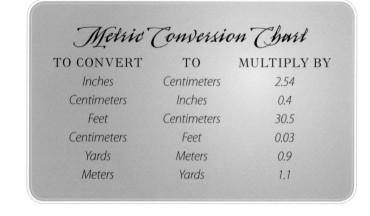

Metric Conversion Chart

TO CONVERT	TO	MULTIPLY BY
Inches	Centimeters	2.54
Centimeters	Inches	0.4
Feet	Centimeters	30.5
Centimeters	Feet	0.03
Yards	Meters	0.9
Meters	Yards	1.1

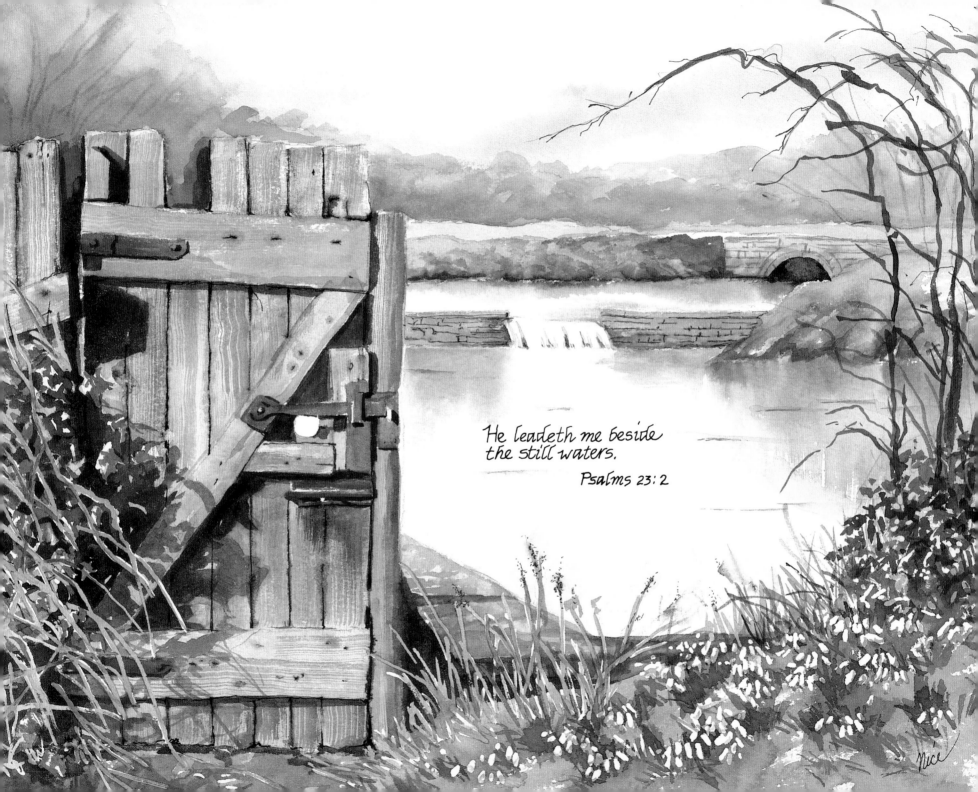

He leadeth me beside
the still waters.

Psalms 23:2

TABLE of *Contents*

Introduction

*L*et me wander down a rambling country road where trees form arches overhead, and wooden fences give way to field and pasture. Better yet, let me turn aside onto paths seldom trod and discover hidden glens, tumbling brooks and distant mountain peaks framed by wooded hills and vast skies. I want to experience the beauty of the world with all my senses, and capture the essence of what I feel and hear and see with pen and brush. I'm a visual person and what I set down on paper will come alive for me over and over again, as I share my artistic endeavors with others. While it is true a good photographer can capture the beauty of a scene, the experienced artist has the ability to eliminate the unnecessary from his landscapes and to enhance the qualities that most appeal to him, making a very personal statement.

I like to bring out the texture of my subjects, as well as their distinctive shapes and colors, so that those who view my work can "feel" the scene as well as see it. Adding texture to a painting is like the chocolate chips in fresh baked cookies. Those sweet, gooey lumps make all the difference. Therefore, texture will have a special emphasis in this book. Most of the texturing techniques within these pages are tried and true favorites of mine, some of which I have used in new ways. I've also included some spontaneous experiments which have turned out well. The creative process is an adventure and I invite you to join me in the fun.

Claudia Nice

This small watercolor landscape was textured with brush stippling, glazing, Pitt pen stippling, spatter and wet-on-wet techniques.

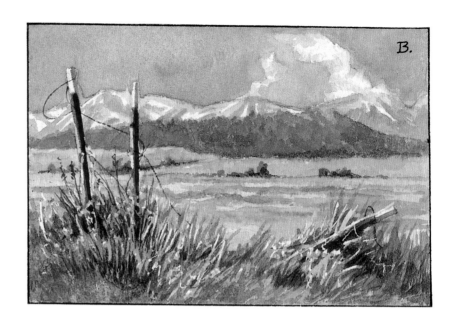

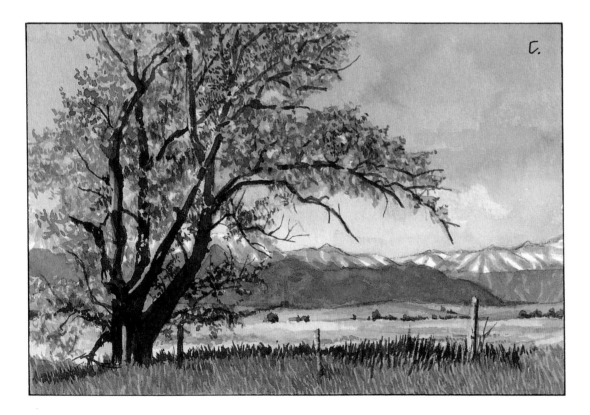

A. <u>Bad</u> – The shapes in this landscape are all horizontal. There is no center of interest, and poor value contrast.

B. <u>Better</u> – By moving in closer and rearranging the fence posts, the painting now has a center of interest and some vertical and diagonal shapes. Value contrast is apparent.

C. <u>Best</u> – In this version, the tree is the center of interest. It adds both horizontal shapes and graceful curves to the landscape. The eye is drawn first to the strong value contrast of the dark trunk. It follows the branches upward and curves with them back to the ground. The dark tree shadow guides the viewer back to the tree. Note the texture strokes in the foliage and foreground grasses.

1 BASIC TOOLS
and
Techniques

There is more to creating a successful landscape than just copying a pretty scene from nature. It needs to have a center of interest and a well thought-out design to support the center of interest, consisting of the following elements:

1. SHAPES—A careful arrangement of horizontal, vertical, diagonal and centered shapes and lines will direct the flow of the painting, leading the eye on a visual pathway throughout the scene and back to the center of interest. Be aware that strong directional lines that exit the edge of the painting may take the viewer's eyes with it.

2. VALUE CONTRAST—Light and shadows give the shapes in the painting form and depth. Abrupt value changes can be used to define hard edges, add focus to the center of interest, and put drama into the landscape. Gradual value changes suggest rounded forms and soft edges. Deep shadow areas tend to recede into a painting and rest the eye, while strong highlights jump forward to pique the viewer's interest. Creative use of value contrast can mean the difference between a ho-hum composition and one that comes alive.

3. COLOR—The selection of color, and the value, temperature, and intensity of each hue, will affect not only the mood of the painting but also its sense of reality, depth and unity. Bright, high-intensity colors will demand attention. Use them mainly in the foreground, leading to or within the center of interest. Repeat the bright hues in a subdued form in the background to create color balance and the illusion of distance. Throwing color into a painting haphazardly will result in visual chaos. Plan a color scheme, considering the time of year, the weather, and the emotion you wish to express in your landscape.

4. TEXTURE—Texture is the surface quality that allows us to tell an orange ball from an orange. Although actual texture can be created by using texturing mediums, most artists give the illusion of texture by using line patterns and a variety of application tools. Texturing adds the finishing touch of reality to a landscape, but must be handled with thought and skill to preserve the credibility of the painting.

In this chapter, we will take a closer look at all the compositional elements listed above, for no one component can stand alone in the creation of a successful landscape. However, the main focus will be on the basic texturing techniques and the tools used to create them. Don't be afraid to try them out before moving on. They say practice makes perfect, but I experiment with textures just because it's fun!

9

Combining the Compositional Elements

1. This outline pencil sketch suggests only the shapes in the composition. It is hard to tell positive shapes from negative ones.

2. The shapes were filled in with flat color washes making the areas more distinguishable.

3. Value contrast was added to the scene, giving the various shapes the illusion of three-dimensional forms. The landscape now has depth. A hint of texture can be seen in the grass, foliage and barn siding.

The same elements were used to paint the landscape on the opposite page, but more attention was given to detail work and the creation of textured areas.

flat shapes

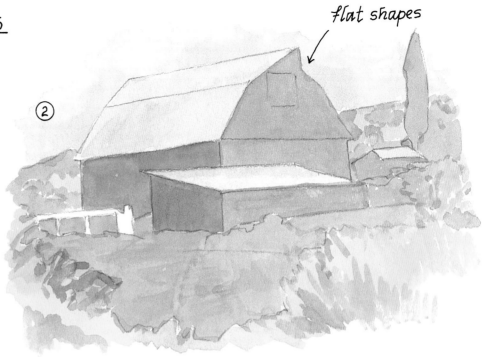

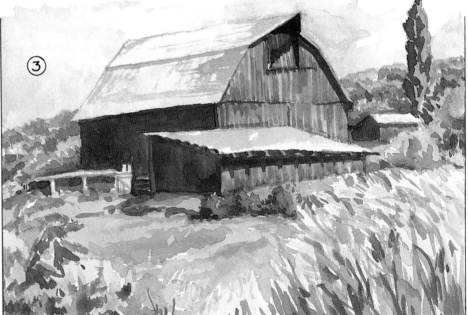

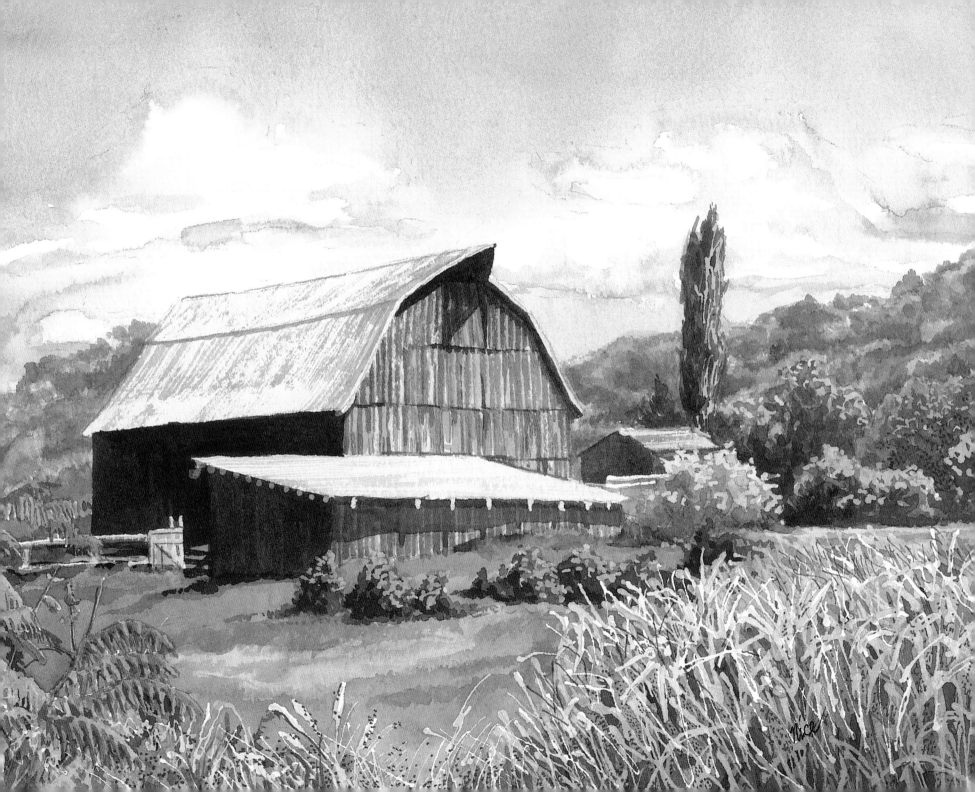

Turning Lines Into Texture

Straight parallel lines suggest flat, smooth surfaces or more textured areas seen at a distance. They need only be as straight as can be drawn freehand.

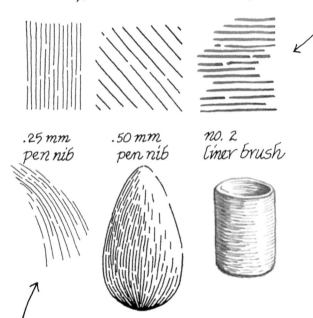

.25 mm pen nib

.50 mm pen nib

No. 2 liner brush

Move lines closer together to darken the value and depict shadows.

Parallel lines are perfect for texturing distant wooded hills.

Below are a few of my favorite line-making tools.

Contour lines work well to indicate smooth, curved surfaces and can be used to suggest motion. The lines are placed side by side and follow the shape of the object they're placed upon. Contour lines drawn vertically add a sense of grace and height to a subject, while horizontal contour lines suggest weight and strength.

contour lines

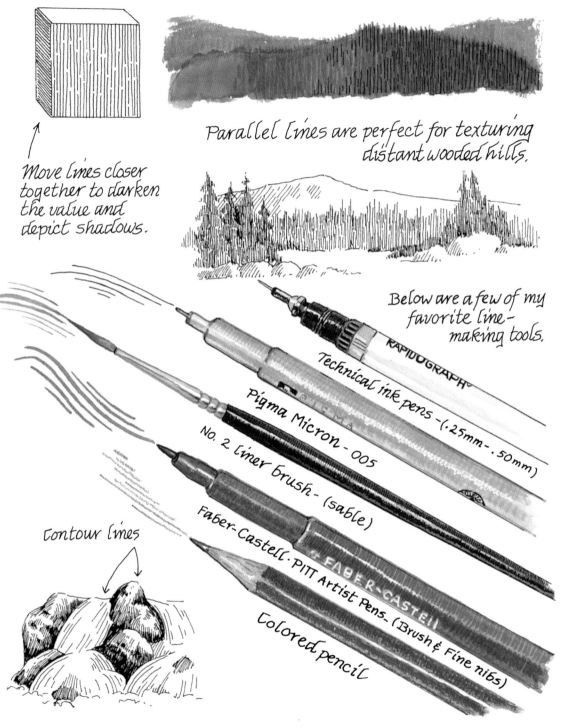

Technical ink pens - (.25mm - .50mm)

Pigma Micron - 005

No. 2 liner brush - (sable)

Faber-Castell PITT Artist Pens - (Brush & Fine nibs)

Colored pencil

Crosshatching occurs when two or more sets of parallel or contour lines are overlapped so that they intersect at different angles. Crosshatching can produce a wide variety of textures ranging from semi-smooth to very rough, depending on the angle at which the lines intersect, the width of the line and the precision of the strokes. Right angles, bold lines, and loose strokes create the roughest texture.

Hatch marks (Parallel lines)

Crosshatching

Stroked with a liner brush.

Crisscross lines

Crisscross lines are a variation of crosshatching in which each mark is placed at a slightly different angle than the ones beside it. The individual lines may be short or long, straight or curved. Crisscross lines provide the illusion of a hair-like or grassy texture. It is a favorite stroke of mine for detailing pasture grass, weed patches and wildflower meadows.

Fine crosshatching (.25mm pen nib)

Honeycomb crosshatching has four or more sets of intersecting lines.

Contour crosshatching

Rough, right angle crosshatching. (.50 mm pen nib)

Rough, loose stroke crosshatching.

This sprig of Rosemary is a criss-cross line variation.

Colored pencil

The light grass lines were masked out using a Masquepen. It is a wonderful masking tool.

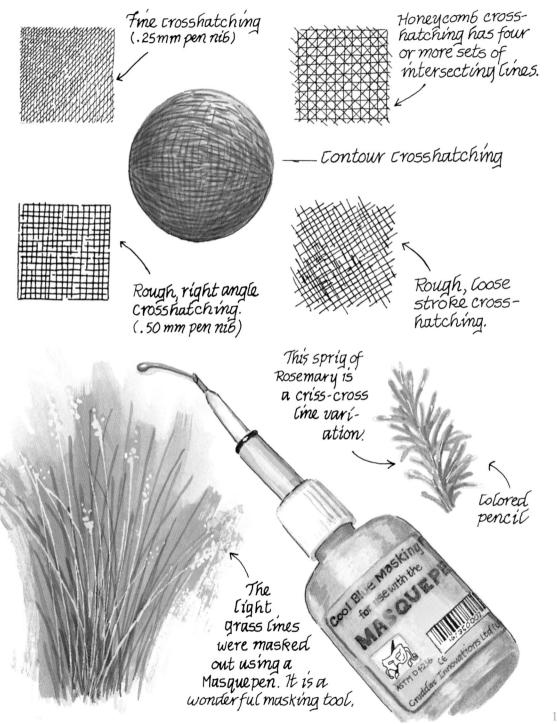

Cool Blue Masking for use with the MASQUEPEN
ASTM D4236 CE
Cruddas Innovations Ltd

<u>Wavy lines</u> are long, flowing marks drawn side by side in such a manner as to form a rippling pattern. They are useful for depicting repetitive grain patterns like those found in wood, marble, tree rings and wind-riffled sand.

Wavy lines stroked with a PITT pen. (brush nib)

<u>Scribble lines</u> are sketchy in appearance, looping and twisting about in a loose, whimsical manner. They may be short, or as long as desired. Scribble lines provide a thick, matted texture which is good for suggesting foliage, moss, and clumps of dry weeds.

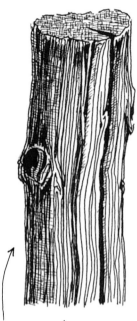

A combination of wavy lines and crosshatching.

Soft, tangled scribble lines.

.25 mm pen nib

Wet wash.

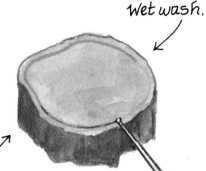

Bruising is an effective way to add grain lines to wood. Simply draw in a wet watercolor wash using a pointed, blunt tool like a stylus, tooth pick or the end of a brush handle. As the tool moves along it will leave a bruised, depressed line that will gather pigment. Note: This only works as long as the paper is wet.

Hint: To create tree rings work from the outer edge to the center.

stylus

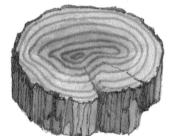

Stylized scribble designs.

Wiry, sharp angle scribble lines.

liner brush

Using the Texture of the Paper

Cold-press and rough watercolor papers have surfaces textured like minute hills and valleys. Applications of paint or pencil over the dry surfaces of these papers provide a coarse, abrasive appearance. The pigment catches on the raised portions of the paper and skips across the valleys. This paper-induced texture is wonderful for suggesting the coarse surface of brick, stone, weathered wood and hard-packed soil.

A PITT pen (brush nib) was rubbed loosely across this dry surface.

Colored pencil was scribbled over this rough, dry paper surface.

Drybrush technique applied over a dry wash.

A razor blade is a handy tool for scraping paper texture into a dry wash. Be gentle, so that the razor only removes the paint from the raised portions of the paper.

To create drybrush textures, fully load a flat brush with paint, blot it well on a paper towel and paint with what pigment is left in the brush.

For a woodgrain effect, gently splay the hairs of the brush apart and drag it gently over the surface of the paper.

Synthetic hair, flat brushes make great drybrushes because they hold less moisture

Use the corner of the razor to scrape in lines and the flat of the blade for wide bands.

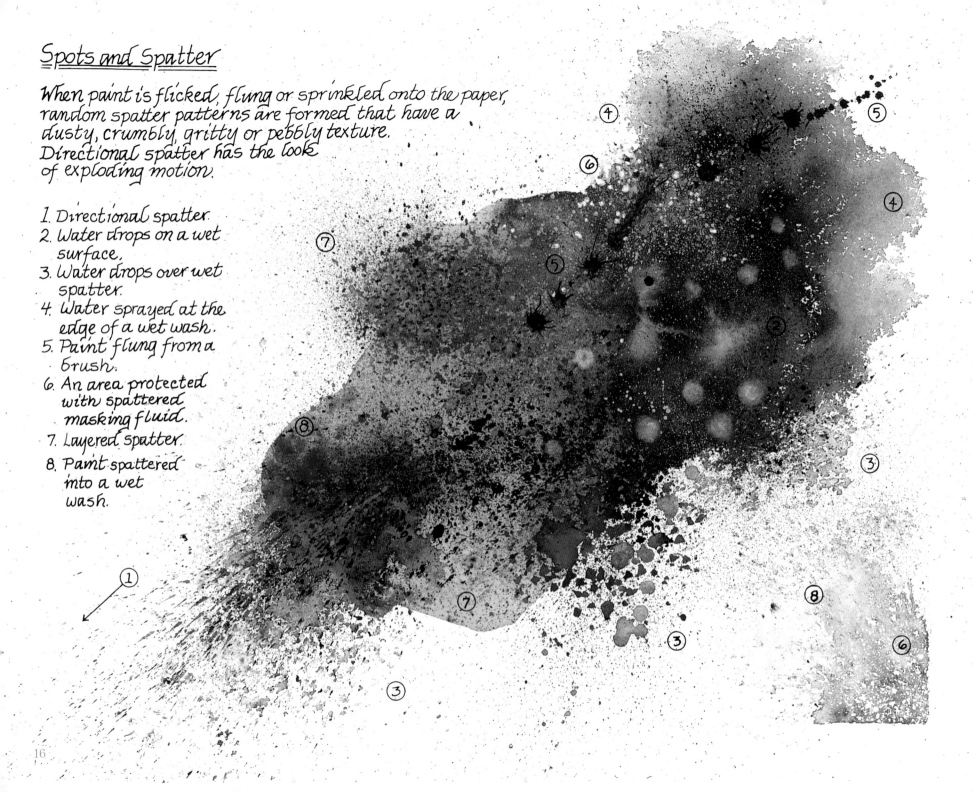

Spots and Spatter

When paint is flicked, flung or sprinkled onto the paper,
random spatter patterns are formed that have a
dusty, crumbly, gritty or pebbly texture.
Directional spatter has the look
of exploding motion.

1. Directional spatter.
2. Water drops on a wet surface.
3. Water drops over wet spatter.
4. Water sprayed at the edge of a wet wash.
5. Paint flung from a brush.
6. An area protected with spattered masking fluid.
7. Layered spatter.
8. Paint spattered into a wet wash.

Fine, far-flung spatter flicked from a toothbrush. (Dry surface)

spots

To create a wide pattern of specks, dip an old tooth brush in a wash puddle of paint and flick the bristles with your thumb while holding it over the paper. The more vigorous the flicking action and the higher above the paper you hold the toothbrush, the more far-flung the pattern will be.

To make controlled, directional spatter, fully load a brush with watercolor wash and flick it off the tip of your finger, nail side down. Start with your finger a finger's width above the paper and lift it higher to widen the pattern. If no flecks appear, try a wetter mix on the brush.

Tap here

NO. 8

To create small spots, fill a large round brush with watercolor wash so that the hairs are fully loaded; hold the brush horizontally over the paper and tap the handle vigorously with your finger or a pencil. Paint drops should fall onto the surface.

Paint spattered onto a damp surface will spread and soften.

¼" flat brush

no. 4 round brush

An important note: Some pigment toxins can be absorbed through the skin. If using cadmium paints or just to stay clean, put on a rubber glove before involving your finger in these spatter techniques.

Dots and Dabs

Dot work, better known among artists as stippling, is achieved by touching a pen or tapping a pencil directly down on the paper and lifting it straight up. If the tool is soft like a sable brush, the mark will be more of a dab than a dot. A series of dab marks is still considered to be stippling.

No. 2 pencil stippling

— Watercolor wash on a leaf shape.

Simple shade work glazed on.

The addition of .25mm dots. (velvety)

Rapidograph pens
.25mm .35mm .50 mm

Micron pen 005

PITT pen- Brush nib

Brush nib- (Tip was held at a slight angle.)

PITT Artist pen- F nib

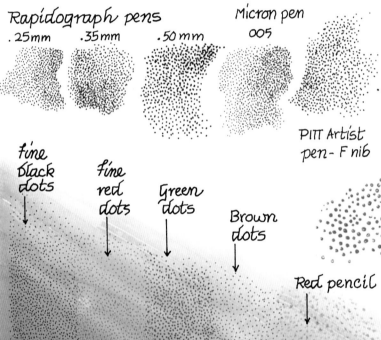

fine black dots

fine red dots

Green dots

Brown dots

Red pencil

Stippling is similar to spatter in its textural appearance, but is much more controlled. Stippling works well to depict a subject composed of numerous small particles such as sand, soil, clouds and water spray. It can also lend a dusty or velvety look to an object. Rust or gritty areas spring to life with the addition of a layer of well placed dots. I also use stippling to unify backgrounds.

← I used a stiff rubber-tipped tool to create these dots. It was dipped in watercolor.

This is a no. 2, taper point, Color Shaper. These tools come in other shapes and sizes.

Note how the application of stippling changes the appearance of this red washed area.

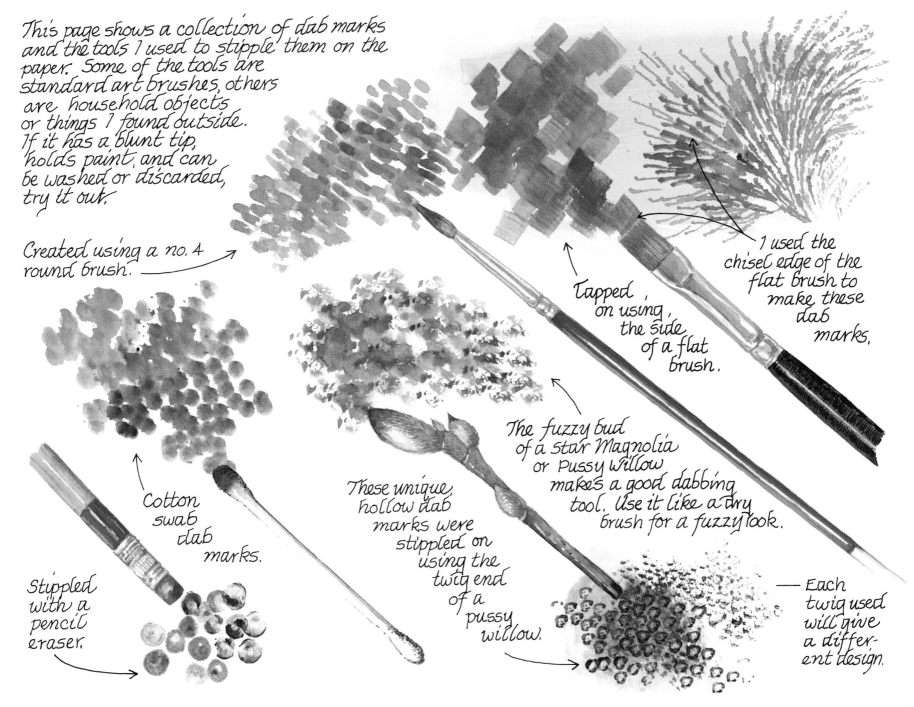

This page shows a collection of dab marks and the tools I used to stipple them on the paper. Some of the tools are standard art brushes, others are household objects or things I found outside. If it has a blunt tip, holds paint, and can be washed or discarded, try it out.

Created using a no. 4 round brush.

Tapped on using the side of a flat brush.

I used the chisel edge of the flat brush to make these dab marks.

Cotton swab dab marks.

Stippled with a pencil eraser.

These unique, hollow dab marks were stippled on using the twig end of a pussy willow.

The fuzzy bud of a star Magnolia or Pussy Willow makes a good dabbing tool. Use it like a dry brush for a fuzzy look.

Each twig used will give a different design.

Stamping

To create stamped texture, paint the surface of an object with acrylic or watercolor paint, blot it gently on a paper towel, and press the painted side firmly to the work surface. Ideally the result is a print of the object's textural design.

Kitchen sponge print

To make a good stamp, an object should be absorbent enough to hold and transfer thin layers of paint. The stamp prints on this page were made using watercolor.

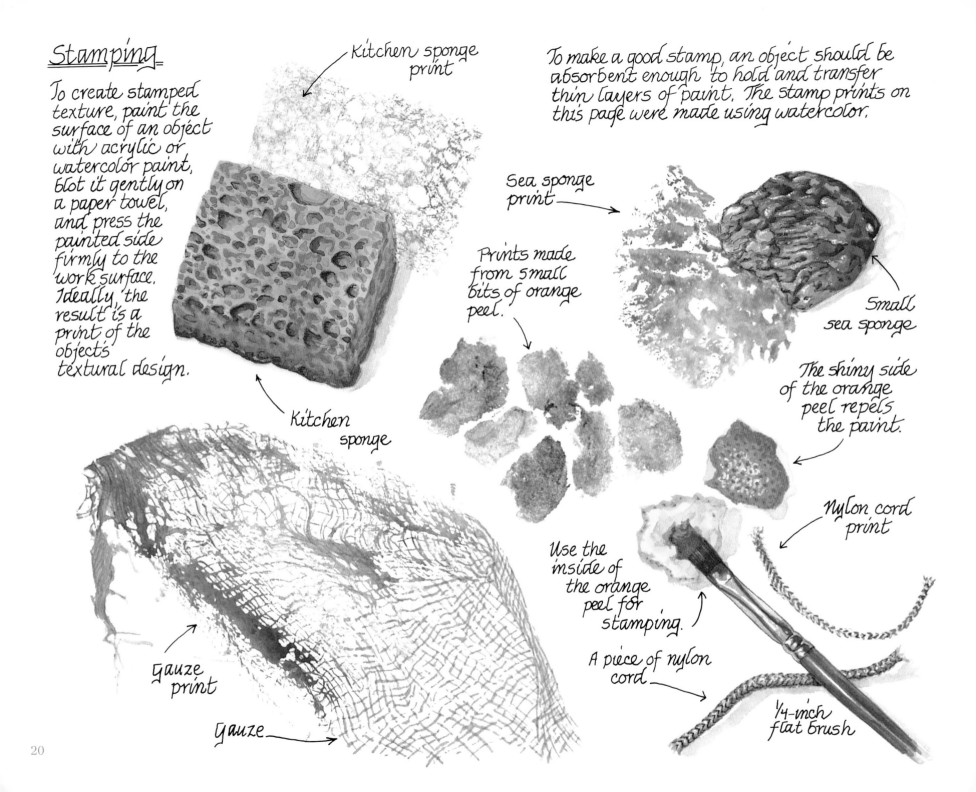

Sea sponge print

Prints made from small bits of orange peel.

Small sea sponge

The shiny side of the orange peel repels the paint.

Kitchen sponge

Nylon cord print

Use the inside of the orange peel for stamping.

A piece of nylon cord

Gauze print

Gauze

1/4-inch flat brush

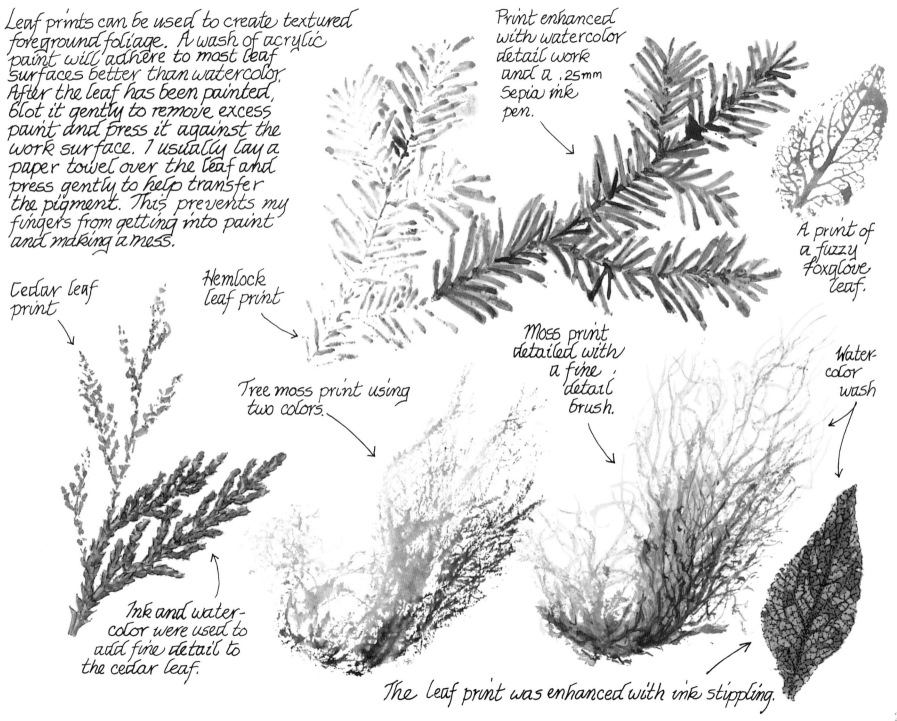

Leaf prints can be used to create textured foreground foliage. A wash of acrylic paint will adhere to most leaf surfaces better than watercolor. After the leaf has been painted, blot it gently to remove excess paint and press it against the work surface. I usually lay a paper towel over the leaf and press gently to help transfer the pigment. This prevents my fingers from getting into paint and making a mess.

Print enhanced with watercolor detail work and a .25mm sepia ink pen.

A print of a fuzzy foxglove leaf.

Cedar leaf print

Hemlock leaf print

Moss print detailed with a fine detail brush.

Tree moss print using two colors.

Watercolor wash

Ink and watercolor were used to add fine detail to the cedar leaf.

The leaf print was enhanced with ink stippling.

21

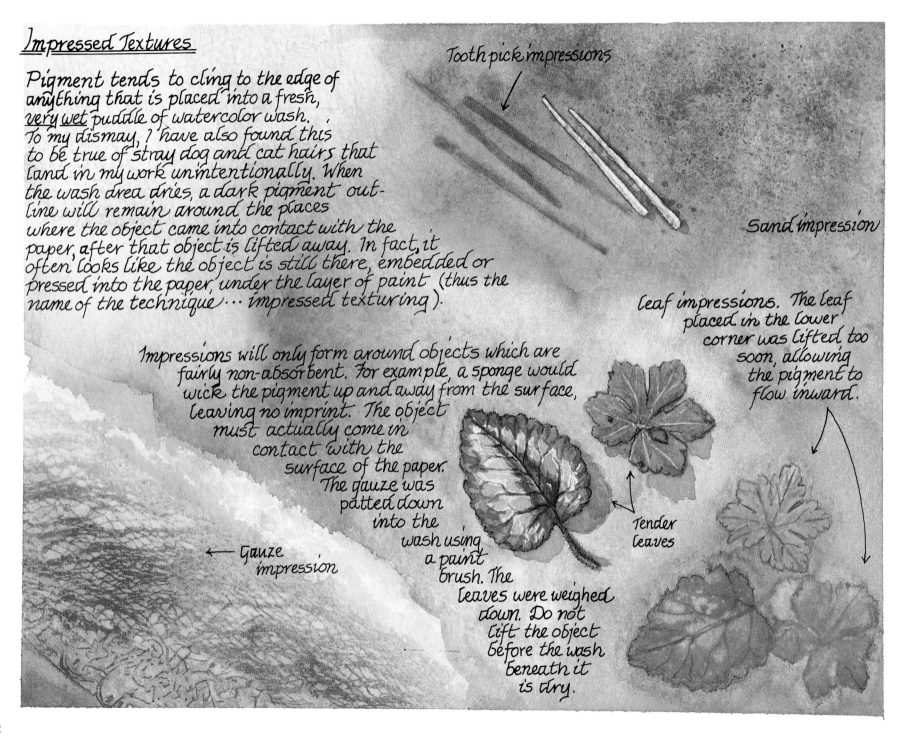

Impressed Textures

Pigment tends to cling to the edge of anything that is placed into a fresh, _very wet_ puddle of watercolor wash. To my dismay, I have also found this to be true of stray dog and cat hairs that land in my work unintentionally. When the wash area dries, a dark pigment outline will remain around the places where the object came into contact with the paper, after that object is lifted away. In fact, it often looks like the object is still there, embedded or pressed into the paper, under the layer of paint (thus the name of the technique ... impressed texturing).

Tooth pick impressions

Sand impression

Impressions will only form around objects which are fairly non-absorbent. For example, a sponge would wick the pigment up and away from the surface, leaving no imprint. The object must actually come in contact with the surface of the paper. The gauze was patted down into the wash using a paint brush. The leaves were weighed down. Do not lift the object before the wash beneath it is dry.

Leaf impressions. The leaf placed in the lower corner was lifted too soon, allowing the pigment to flow inward.

← Gauze impression

Tender leaves

22

Plastic wrap impressions remind me of pebbly soil or worn cobble stones. Here are the steps involved in making a plastic wrap impression.

1. Lay down an area of wet water-color wash.

2. While the paint is still wet, place a crumpled up length of plastic wrap in it. Secure it in place with masking tape, but don't put enough pressure on it to flatten it down. Leave the plastic wrap undisturbed until the paint beneath it is totally dry. Peeking will release the pigment and spoil the image.

3. The result should be a group of dark irregular shapes.

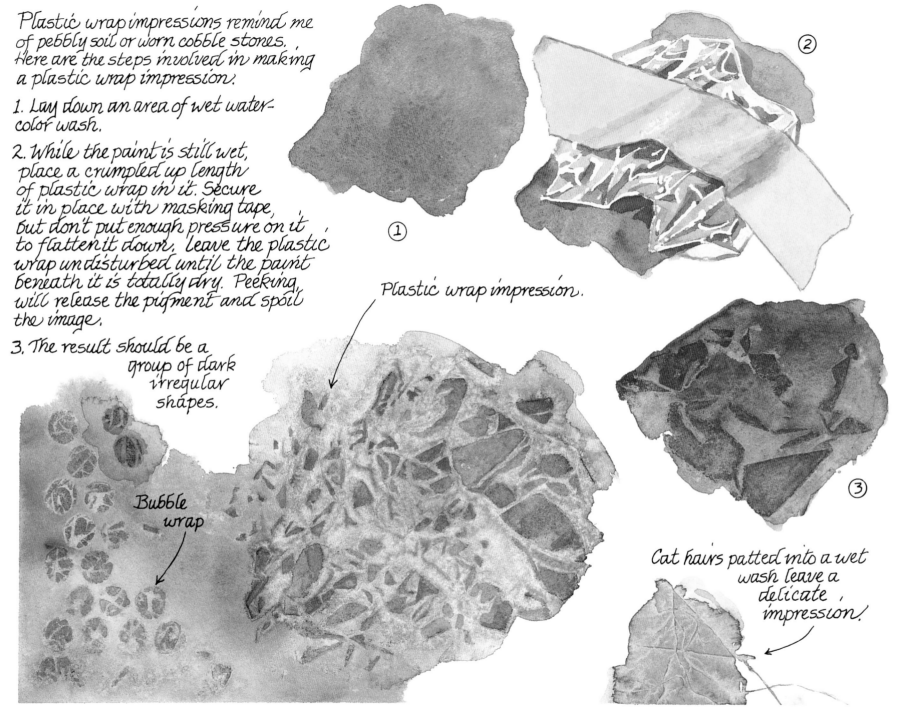

①

②

Plastic wrap impression.

③

Bubble wrap

Cat hairs patted into a wet wash leave a delicate impression.

23

Masking

To protect white paper areas, or shapes within a dry wash from being covered up by additional paint layers, apply a protective shield (mask). I use the Masquepen or Winsor & Newton Art Masking Fluid. Masking fluid is left in place until the final layer of paint covering it is very dry. Masking fluid can be removed by dabbing it with the sticky side of a strip of masking tape.

Protect brushes used to apply masking fluid by first filling the brush-head with soap suds. Don't use good sable brushes for this job!

Masquepen masking fluid was applied over a dry wash.

After the masking fluid was dry, additional washes were brushed over it. When the paint was dry, the masking fluid was removed and details were added to the leaves.

Aquacover liquid watercolor paper will reclaim white areas.

A watercolor wash was brushed over the tape pieces.

Background shapes were painted in and the masking tape peeled off.

A pale wash and details were painted into the masked area.

Masking tape also makes a good protective shield.

These pieces of masking tape were torn from a short strip and smoothed into place.

① ② ③

CREATIVE MARK
Aquacover
Liquid Watercolor Paint

stippling

Lifting

Lifting is the removal of pigment from previously painted areas to create patches of lighter value. This is most easily accomplished when the pigment is blotted up from a fresh, moist wash using some kind of absorbent material. Pigment may be removed from a dry wash, providing the paint is not too sparse, by scrubbing an area with the chisel end of a damp, sturdy, flat brush, and blotting the loosened pigment away with a tissue.

The pigment is being lifted up, from this moist wash puddle using a damp, clean, flat brush. Note the soft edges the blotting technique creates.

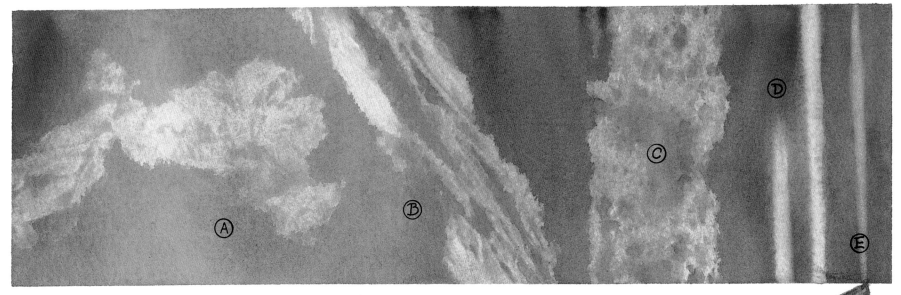

A. Area was blotted with a crumpled tissue.

B. Area was blotted with a tissue which had been pulled into pleated folds.

C. Area was blotted with a damp kitchen sponge.

D. Area was lifted using a round brush.

E. This stripe was lifted out of a dry wash by working the pigment loose with a moist, firm, flat brush.

Chisel edge

Free Flow Textures

When a colored wash is laid on the surface of a moisture filled paper (wet-on-wet technique), the pigment will flow spontaneously over the surface, creating soft edged, free form patterns. Keep in mind that a moisture filled paper should have a wet sheen on the surface, but should not harbor puddles of standing water.

Subtances such as salt or alcohol can cause spontaneous free-flow textures to occur within a moist wash puddle.

Salt sprinkled into a moist water color wash and left until dry.

Pre-moistened bits of rock salt placed in a moist wash and left in place until dry.

Alcohol drops, dripped into a moist wash.

A bloom is created when water is added to a wash after the pigment has begun to settle against the paper. The added water lifts the pigment and floats it to the edges.

Wet on wet pigment flow. The texture is soft and cloud-like.

Pigment has floated to the edge.

Spraying fine water drops at the edge of a wet wash creates a lacy texture.

To enable you to do your best work, choose a water-color paint which is rich in pigment and has been milled to a good consistency. I used M. Graham and Winsor & Newton watercolors to illustrate the pages of this book.

Koh-I-noor Universal Black India (3080) is my favorite technical pen ink. It is very permanent.

Acrylic inks can also be used as a paint, and applied with a brush.

For a light-fast, permanent colored ink, I recommend Daler Rowney FW Artist's Acrylic Ink. Use only the transparent colors in technical pens.

Pen Blending

When pen lines are drawn over a moist paper surface, the pigment flares outward spontaneously to create soft, fuzzy-looking bursts. I call this technique pen blending because the frayed lines merge beautifully into free-flow watercolor backgrounds.

When pen blending with numerous colored inks, a fine nibbed dip pen works well and cleans up quickly.

Lines A & B were drawn using a dip pen. Lines C & D were drawn with a .25 mm Rapidograph pen. Larger pen sizes create larger flares.

Pen blending ~ Ink lines drawn over a moist surface.

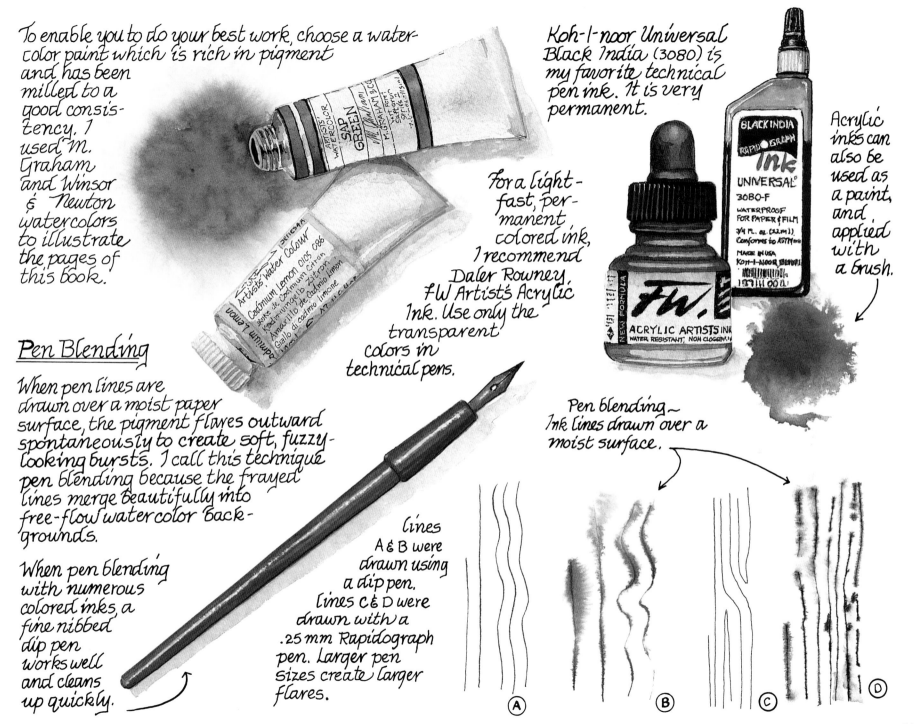

A B C D

27

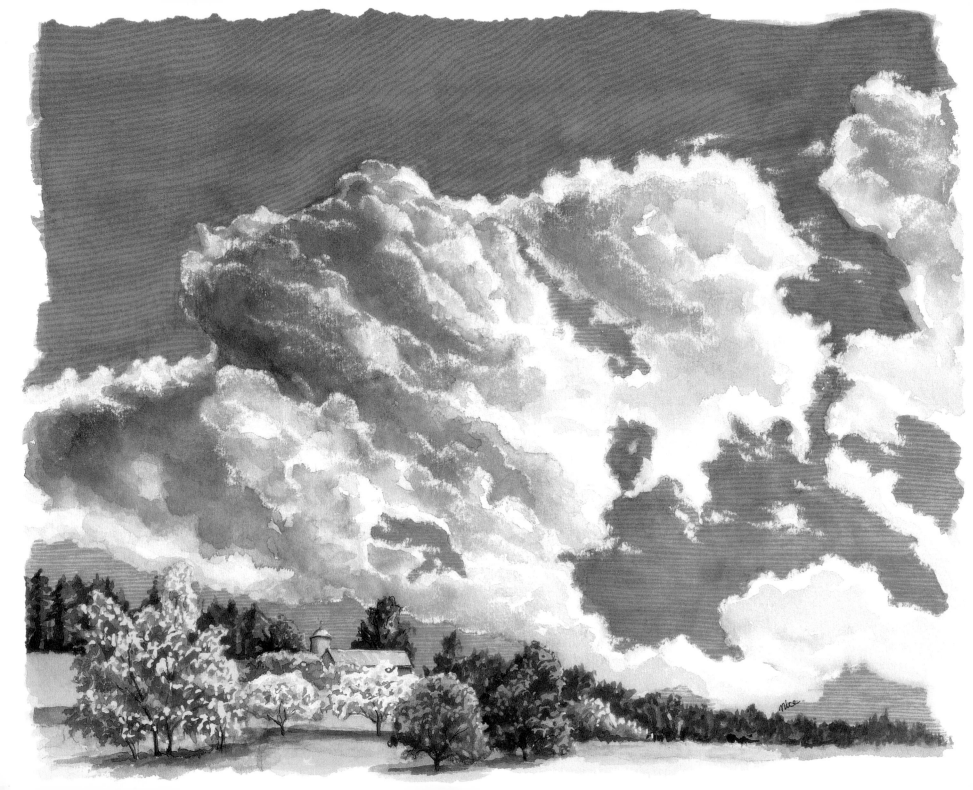

2 *Creative* CLOUDS and SKIES

1 These storm clouds subtly reflect the colors of the hills and fields in hues of dusky peach, ochre-violet and muted blue-violet.

2 A blue sky fades gradually in intensity, its brightest hue being overhead and its palest coloration near the horizon.

3 This summer sky has both wispy cirrus clouds and fluffy, flat-bottomed cumulus clouds. Note how firm the edges of the distant cumulus clouds appear.

4 Back-lit clouds glow along the thinner edges and darken in the thicker portions, the most dense areas being the darkest.

Clouds don't have the kind of texture that can be held in the hand and examined with the fingers. The damp chill of a heavy fog against the cheek is the closest one can come to feeling the texture of a cloud. However, when asked to describe a cloud, the words "wispy," "cotton-like," and "billowy" come to mind. In an attempt to capture the cottony softness of a cloud, a child will draw a stylized puff, oval in shape, with hard-edged bumps all the way around the edge. The mature artist must suggest the fleecy translucency of clouds with a bit more skill in order to convince the viewer.

Observing the shape, color and texture of various clouds, along with their edge qualities and internal value changes, is the first step in drawing and painting believable clouds. More often than not, clouds flare outward along the top and sides and are rather flat along the bottom, especially the fluffy white cumulus clouds seen in summer skies. While most clouds have soft or vaporous edges, clouds seen at a distance (near the horizon) can appear to have crisp, semi-hard edges. Highlights and shadows within the clouds depend on light direction and the thickness of the clouds.

Not all clouds are white and gray. Atmospheric conditions, reflections, and the sun's position in the sky can subtly tint the vaporous bodies most any color. Add a little dust, smoke, haze, or water vapor to reflect the rays of the setting sun, and the colors can be anything but subtle. Study the clouds seen in the photos at right and the ones that form in your local skies, then turn the pages of this chapter and I will show you some fun and easy ways to paint them.

BLUSTERY SPRING DAY
Watercolor textured with wavy Pitt Pen lines in the sky. Cloud edges were softened by scratching them with a razor blade.

Creating Cirrus Clouds

The wispy-thin, elongated clouds that appear high in the sky are called Cirrus. They are made up of ice crystals. It's easy to duplicate their fragile appearance by lifting them out of a wet wash with a tissue. Here's how---

① Create a damp work surface by brushing water over the paper, letting it absorb and blotting off the moisture on top with a paper towel. The paper should feel damp, but not have a wet sheen on the surface.

② Have a facial tissue ready for blotting. It should be crumpled and stretched lengthwise into folds.

③ Lay down a flat wash of Cobalt Blue mixed with a touch of Phthalocyanine Blue (blue-green). The damp surface will help the wash go on smoothly. Don't overwork the paint.

④ While it's still moist, gently blot Cirrus cloud shapes out of the wash, using the crumpled tissue. Don't press too hard!

HIGH COUNTRY MEADOW
Many texturing techniques were used in this watercolor landscape, including tissue blotting (sky), masking (tree and foliage), bruising (tree) and pen blending (tree and dead branches).

Cloud Textures in Pen and Ink

The most common type of cloud to be drawn or painted is the fair weather cumulus cloud (right). It has a heaped-up, fluffy appearance, with a rather flat base. Pen and ink stipple marks work well to suggest both the sky surrounding the cumulus clouds and the shadows that define the clouds.

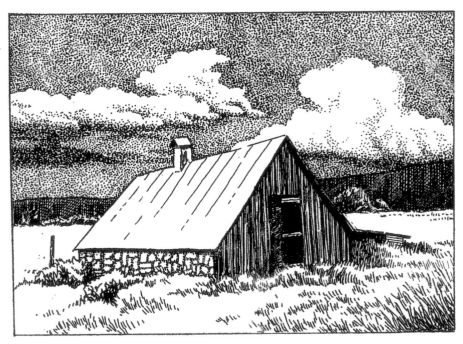

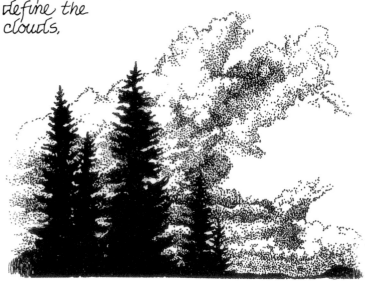

Rapidograph pens, sizes .25, .35 and .50mm were used.

Cumulus congestus clouds (above), build up vertically, forming billowy cloud towers. They may signal an advancing storm, adding drama to the scene.

Clouds from which some form of precipitation is falling are called nimbus clouds. Cumulonimbus clouds may be accompanied by thunder and lightning (right). Diagonal, parallel lines work well to suggest both the intensity of such storm clouds, and the deluge of rain or hail falling from them.

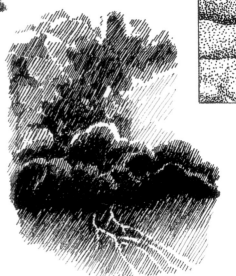

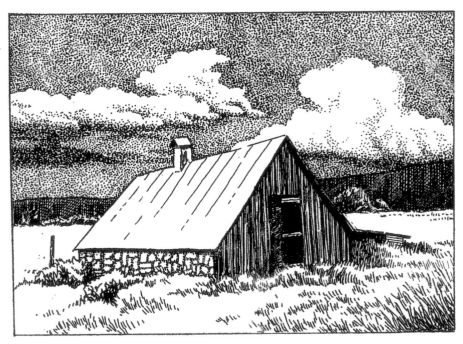

Stratus clouds are sheet-like clouds that may cover the whole sky like a fog. Combined with cumulus clouds (stratocumulus), they have a layered appearance of white through dark gray shapes. Stippling works well to depict such cloud-bound skies as shown above.

Desert scenes, which are full of gritty and prickly textures, are a perfect place to incorporate **pen stippling**. In the scene to the right, I used blue Pitt pens, (brush nib) to overlay the background hills. The ground and cactus areas were textured with Rapidograph stippling in Sepia and black ink. A bit of dot work in the clouds adds textural balance. I used the following process.

① Dampen the sky area and lay down a pale Payne's Gray wash of watercolor.

② Use a narrow band of gathered tissue to blot out lighter clouds.

③ When the preliminary wash is dry, glaze in a few Cobalt Blue streaks to suggest areas of sky.

④ Use a .25 mm Rapidograph pen and India Ink to add stippling to the dark cloud bases.

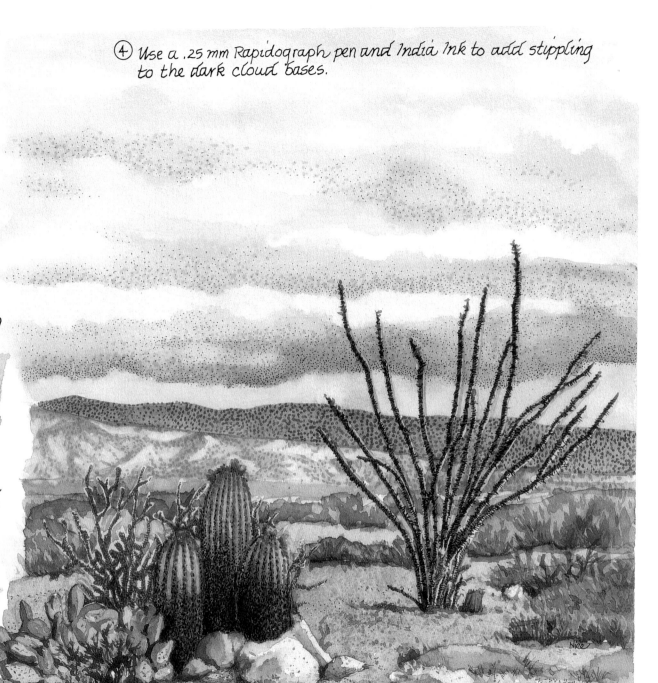

Note: A glaze is a thin, transparent wash applied over dry paint.

Wet-on-wet
Water Bloom
Clouds

This technique is perfect for creating fluffy cumulus clouds.

① Begin with a light pencil cloud sketch. Moisten the sky except in the cloud areas and blot off any standing water.

② Lay a Cobalt Blue/ Phthalocyanine Blue watercolor wash in the sky area right up to the cloud lines.

③ While the wash is still moist, brush a little water along the top edge of the clouds, creating a bloom that pushes into the sky area. More water and tilting the paper downward, will create a bigger bloom. Let the paper dry and erase the pencil lines.

④ Remoisten the clouds and stroke a little Payne's Gray along the base. The darker and wider the gray base appears, the more ominous the cloud will look. Don't use a hair dryer to hasten drying time. It will hinder the effect. Tissues can be used to blot and lighten dark areas.

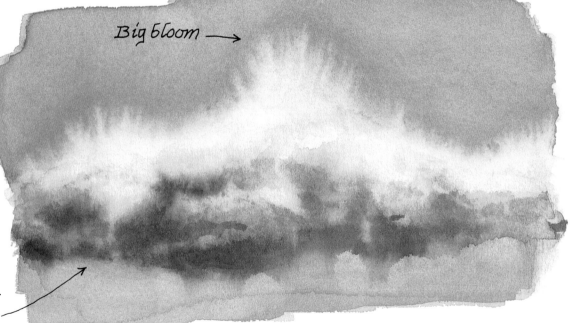

Big bloom →

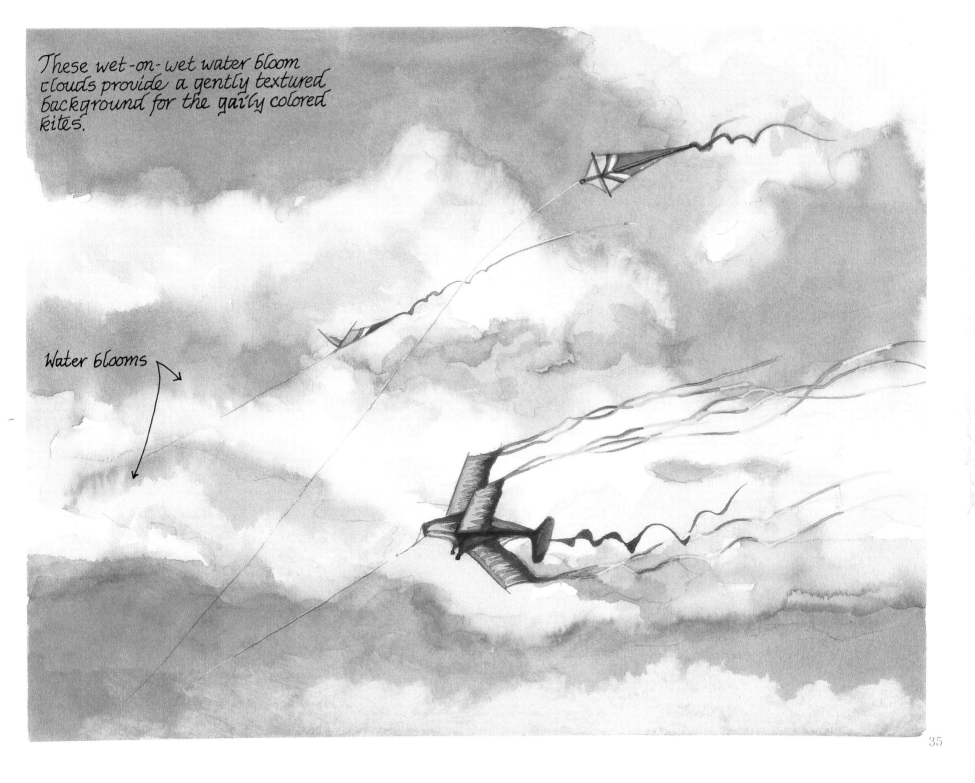

These wet-on-wet water bloom clouds provide a gently textured background for the gaily colored kites.

Water blooms

Creating Storm Clouds

① Begin by painting a Cobalt Blue/Phthalo Blue sky with an advancing sweep of white cumulus clouds. Use the wet-on-wet bloom technique shown on page 34. Let it dry.

② Add a touch of blue-violet (Dioxazine Purple plus Ultramarine Blue) to a wash of orange watercolor. Glaze the resulting burnt peach hue over the base of the clouds.

③ Make a medium dark wash of blue-violet, and mute it slightly by adding orange. Use a no. 4 round brush to tap it unevenly across the dry cloud base. Work quickly and move to step 4 before the wash dries.

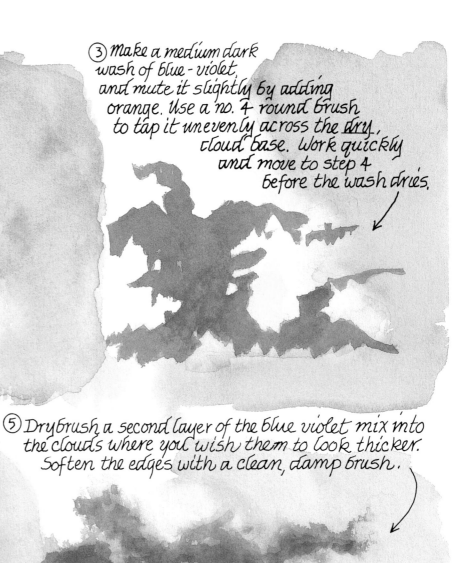

④ Gently spritz the blue-violet areas with water sprayed from a spray-mister bottle and let it flow. Avoid over-spraying and creating puddles.

⑤ Drybrush a second layer of the blue violet mix into the clouds where you wish them to look thicker. Soften the edges with a clean, damp brush.

Dab the bottom edge of the cloud with a tissue to prevent the wash from running downward.

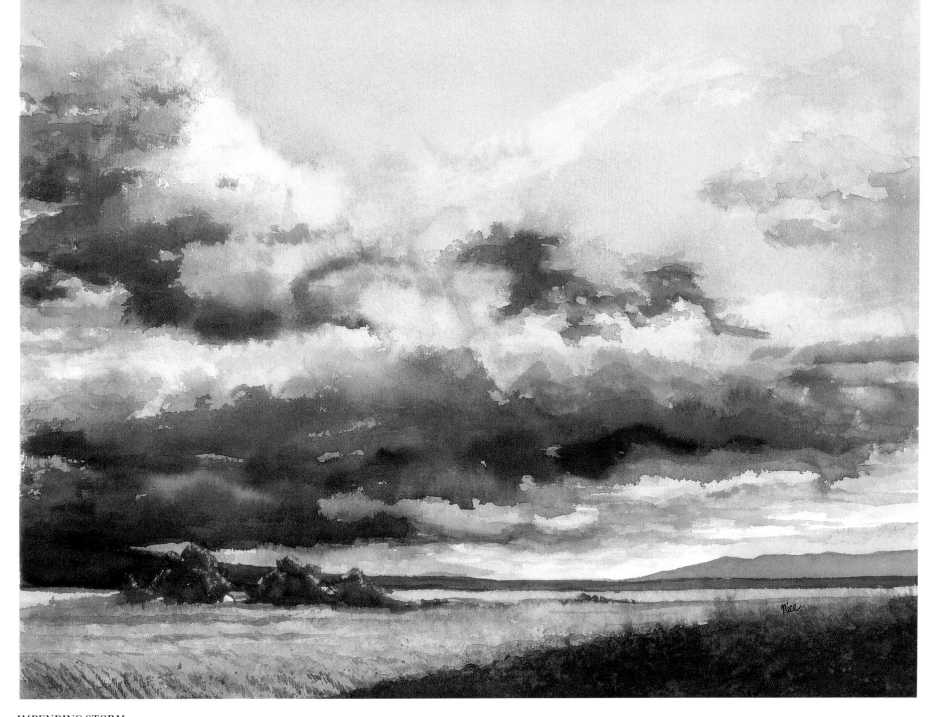

IMPENDING STORM
The texturing techniques used in this watercolor cloudscape include tissue blotting, wet-on-wet water blooms, water sprayed into wet areas, and dry brushing.

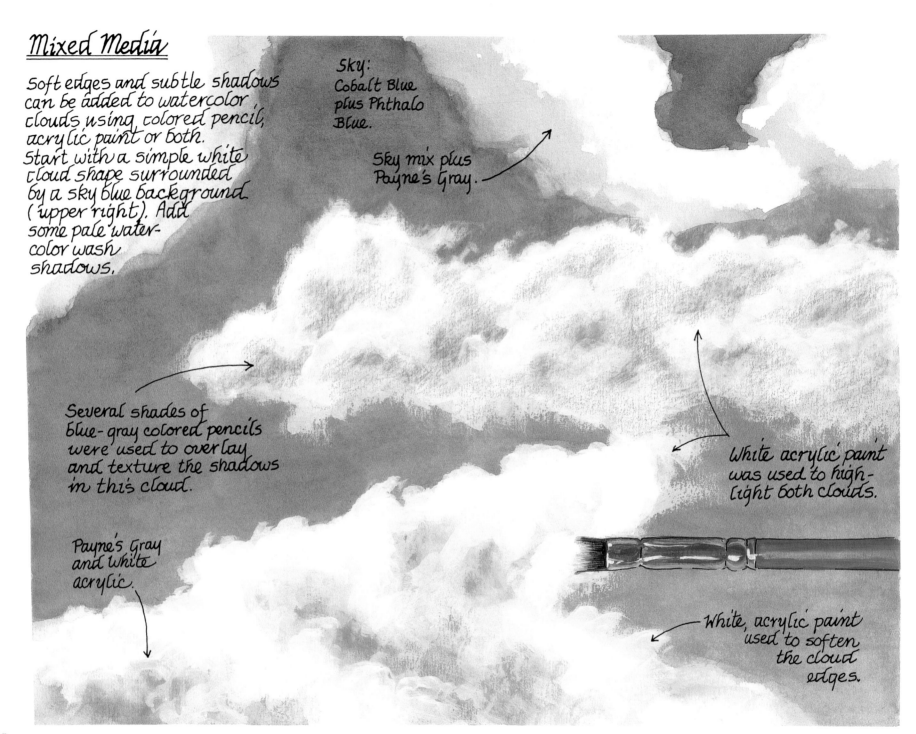

Mixed Media

Soft edges and subtle shadows can be added to watercolor clouds using colored pencil, acrylic paint or both. Start with a simple white cloud shape surrounded by a sky blue background (upper right). Add some pale water-color wash shadows.

Sky:
Cobalt Blue plus Phthalo Blue.

Sky mix plus Payne's Gray.

Several shades of blue-gray colored pencils were used to overlay and texture the shadows in this cloud.

White acrylic paint was used to high-light both clouds.

Payne's Gray and white acrylic.

White, acrylic paint used to soften the cloud edges.

Capture a Rainbow

Using watercolor glazes is an easy way to suggest the translucent colors of a rainbow. Yellow is the middle color in the rainbow and often the most distinct.

① Begin by painting a pale yellow bow across the dry paper surface using a no. 4 round brush. Quickly soften the edges with a clean, damp, round brush. Let the paint dry.

② Glaze a wash of Quinacridone Rose watercolor along the top of the bow, overlapping the yellow paint slightly. The overlapped area will appear orange. Soften the rose edges with a clean, damp brush.

③ Work Cobalt Blue along the bottom edge of the bow in the same manner as the rose. The overlapped area will appear green.

The trees are textured with inked scribble lines (.25mm).

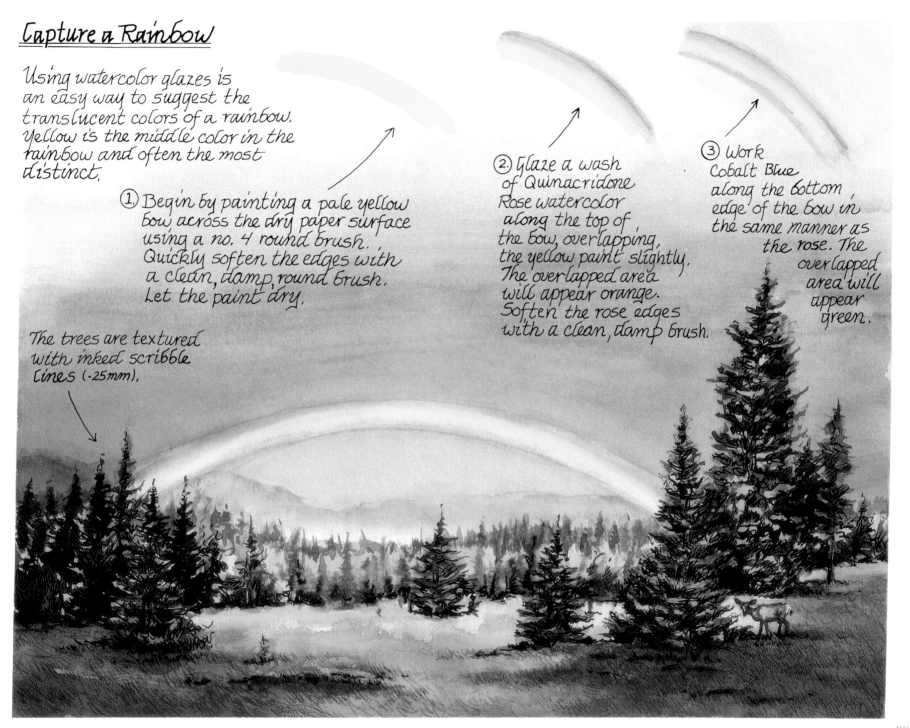

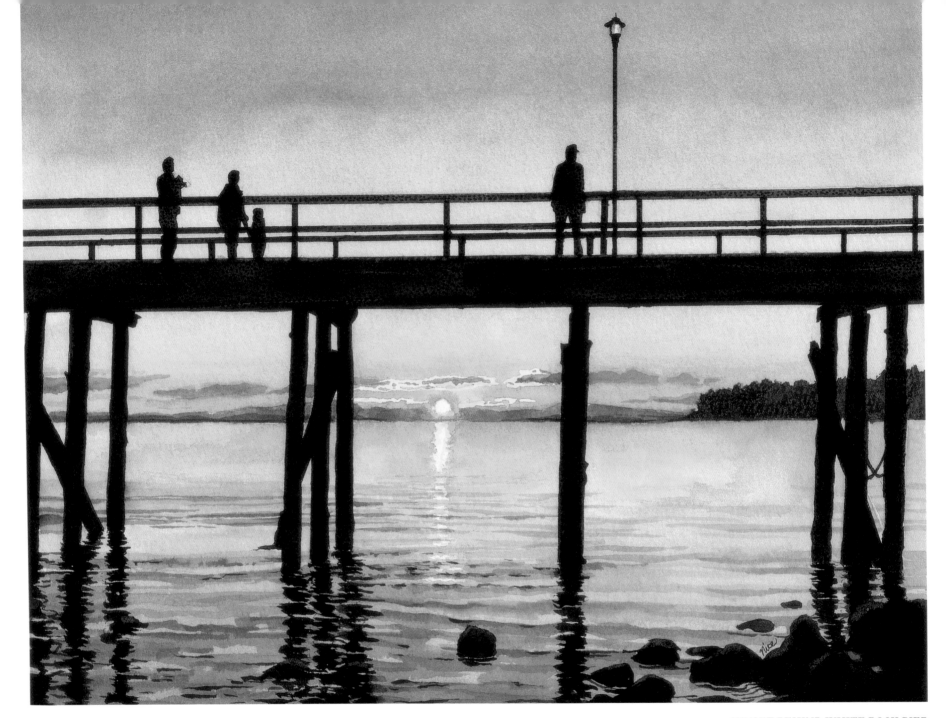

SUNSET BEHIND WHITE ROCK PIER
The silhouettes were textured with pen stippling in black India ink. Sienna pencilwork highlights the closest hill and beach rocks.

Creating a Gradual Color Change Sky

The soft, smooth texture of a graduated watercolor flat wash is the perfect background for a sunset scene. Here are the steps...

① Sketch a round sun shape on the horizon, distant hills, and a few long, narrow clouds. Mask them in with masking fluid or shapes cut from masking tape.

② Mix three paint wash puddles (lots of water in the mix).

Cobalt Blue

Cadmium yellow plus a touch of Quinacridone Rose (peach mix).

More Rose in the mix.

Overlap area.

Paper fiber marks are OK

Do not try to correct dark spots or play in the wash after it has been laid down. The pigment will redistribute unevenly!

③ Tape the paper to a backboard. Predampen the sky and use a flat brush to lay a brush width of Cobalt Blue across the top of the sky. Tilt the paper so that a line of excess paint forms along the bottom edge. Overlap each consecutive stroke so that the excess paint is carried downward. Work quickly. ④ To make the color change, stroke the peach mix alongside the last blue stroke, overlapping them slightly. The colors will blend.

④

⑤ Use the rosy peach color for the final stroke. Use a tissue to blot a halo around the sun.

Green flash

⑥ Remove the masking and paint the halo and adjoining cloud edges Cadmium Yellow. Add a green flash if you like.

⑦ Paint the clouds and hills closest to the sun a rose/violet mix, blending to a blue/violet mix in the outer areas.

For a water scene, mask out a white sun reflection strip.

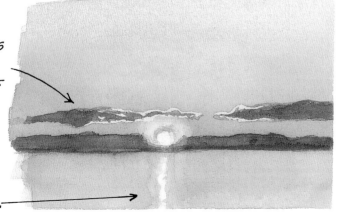

Sunsets That Shimmer

① Begin with a simple pencil sketch with plenty of stretched out, horizontal clouds, and a few interesting silhouettes.

② Use masking fluid and a scribbly stroke to mask the small horizon clouds and the edges of the cloud banks.

③ Paint the sky in a flat, graduated, color-change wash. Start with blue-violet at the top, then switch to pale violet, and finally to yellow (muted with violet).

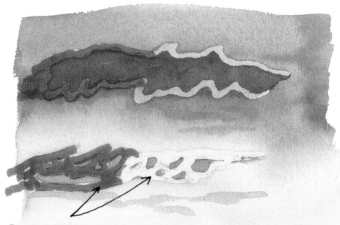

④ Paint the cloud banks with mixtures of violet muted with yellow. Remove the mask, making sure the surrounding paint is dry. Paint the lower clouds with a pale yellow wash. Add a little pale violet to the yellow wash and paint the edges of the cloud banks. The edges will be crisp, giving the clouds a shimmery appearance.

⑤ The silhouettes are filled in using a brown Pitt pen (brush nib) and then overlaid with black ink, leaving a little brown showing at the edges.

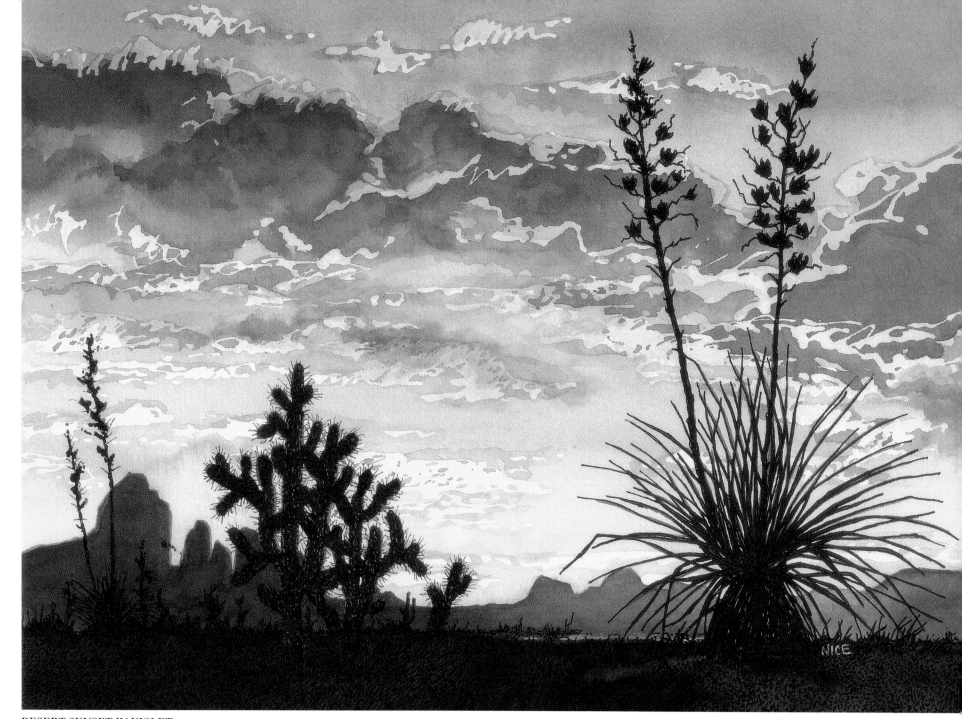

DESERT SUNSET IN VIOLET
Watercolor with pen and ink texturing in the foreground.

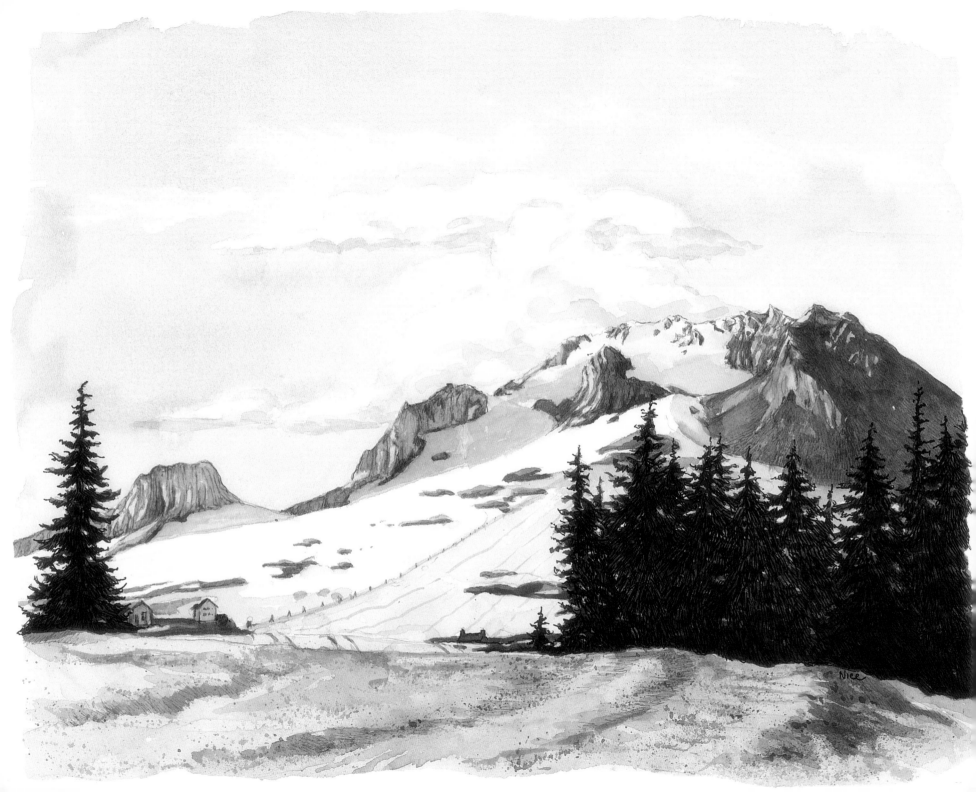

3 *Majestic* MOUNTAINS, HILLS and MESAS

In this chapter, most of the texturing you will see will be soft and subtle, because mountains, rolling hills, and statuesque mesas are used primarily for landscape backgrounds. Distance and the atmospheric haze through which these formations are viewed erases much of their rugged qualities, leaving only a general outline and muted colors to hint at their true nature. You will find step-by-step demonstrations on how to accomplish this on several of the following pages.

Having lived many years on the forested slopes of Mt. Hood, a majestic volcanic peak in the Oregon Cascade range, I have climbed onto the shoulders of the mountain and painted her close up. The watercolor landscape on the facing page is an example of such an adventure. After laying down the foundation in watercolor, I mixed brown and purple ink and penned it over a damp surface to "pen blend" texture into the rocky outcroppings. I also textured the trees with scribbly India ink lines. It was both exciting and humbling to paint the mountain face to face, on location. It commanded my respect and the center of interest in the landscape.

TIMBERLINE
Watercolor, pen and ink.

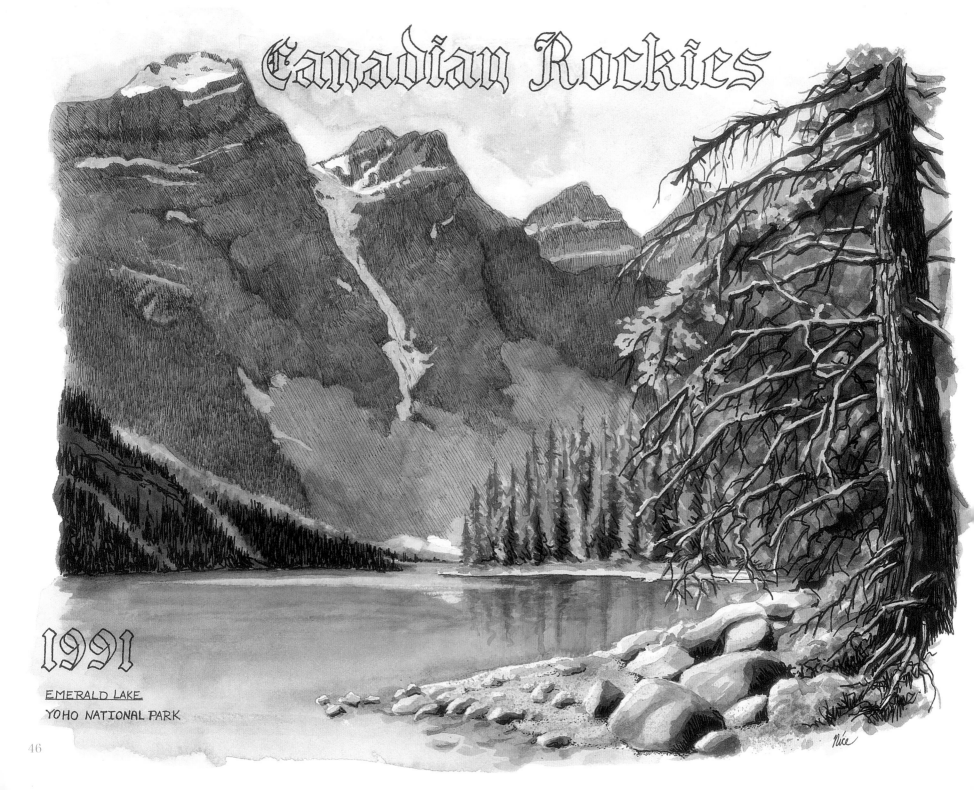

Canadian Rockies

1991

EMERALD LAKE
YOHO NATIONAL PARK

Distant Mountains

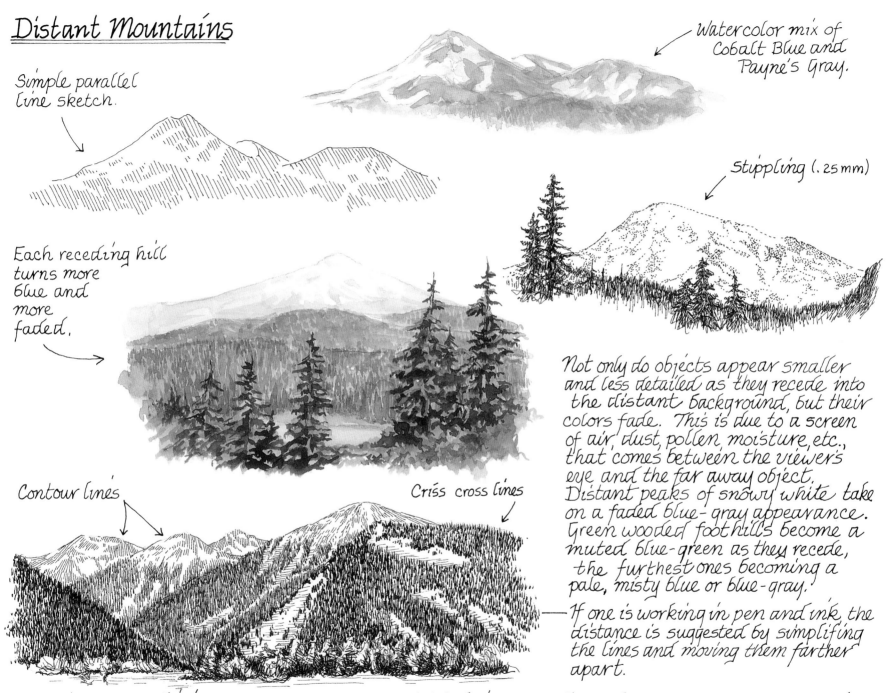

Watercolor mix of Cobalt Blue and Payne's Gray.

Simple parallel line sketch.

Stippling (.25 mm)

Each receding hill turns more blue and more faded.

Contour lines

Criss cross lines

Not only do objects appear smaller and less detailed as they recede into the distant background, but their colors fade. This is due to a screen of air, dust, pollen, moisture, etc., that comes between the viewer's eye and the far away object. Distant peaks of snowy white take on a faded blue-gray appearance. Green wooded foothills become a muted blue-green as they recede, the furthest ones becoming a pale, misty blue or blue-gray.

— If one is working in pen and ink, the distance is suggested by simplifying the lines and moving them farther apart.

Opposite page: This is a page from one of my sketchbook journals. The peaks are both watercolor and ink.

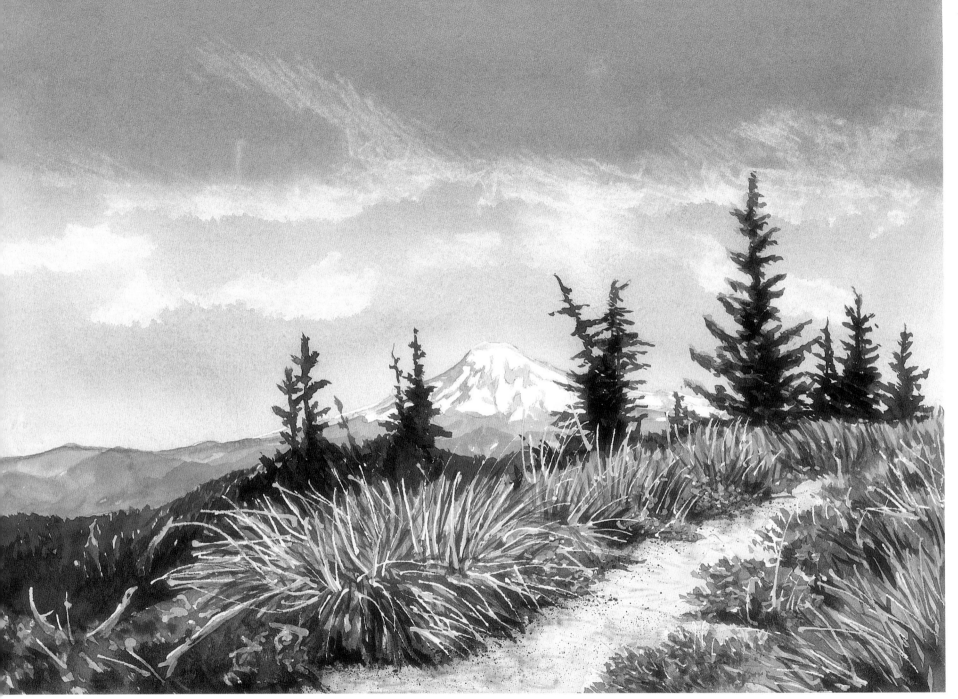

VIEW FROM THE RIDGE TRAIL

This pre-eruption likeness of Mt. St. Helens was painted using a Cobalt Blue/Ultramarine Blue glaze. The light-colored beargrass blades were masked. A twisted tissue was used to lift out the cirrus clouds.

Glaze a Snowy Mountain

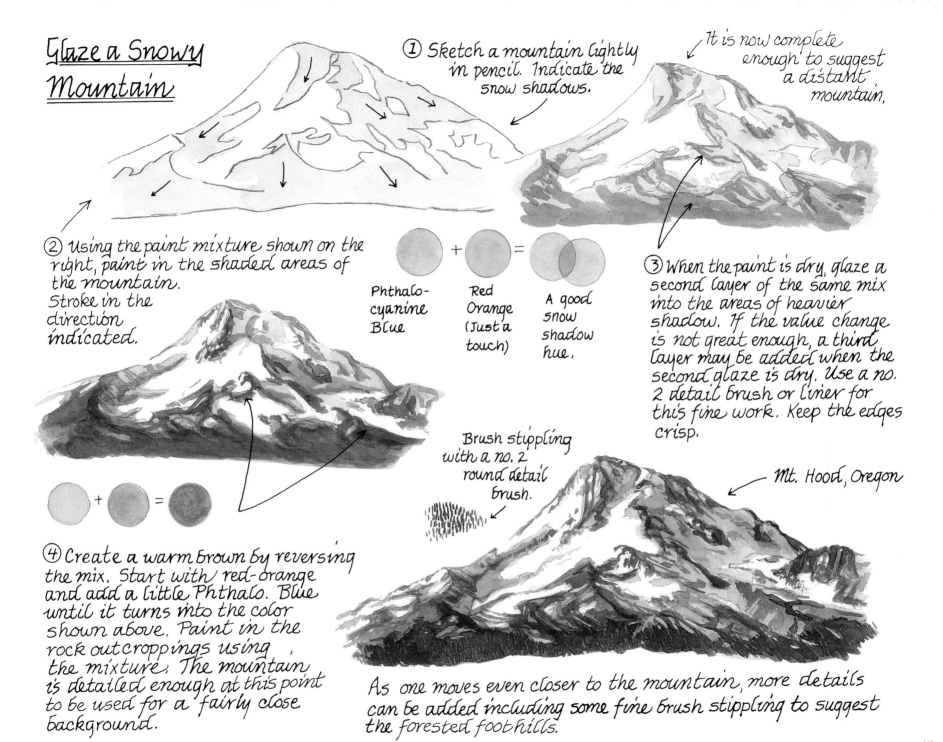

① Sketch a mountain lightly in pencil. Indicate the snow shadows.

It is now complete enough to suggest a distant mountain.

② Using the paint mixture shown on the right, paint in the shaded areas of the mountain. Stroke in the direction indicated.

Phthalo-cyanine Blue + Red Orange (Just a touch) = A good snow shadow hue.

③ When the paint is dry, glaze a second layer of the same mix into the areas of heavier shadow. If the value change is not great enough, a third layer may be added when the second glaze is dry. Use a no. 2 detail brush or liner for this fine work. Keep the edges crisp.

Brush stippling with a no. 2 round detail brush.

Mt. Hood, Oregon

④ Create a warm brown by reversing the mix. Start with red-orange and add a little Phthalo Blue until it turns into the color shown above. Paint in the rock outcroppings using the mixture. The mountain is detailed enough at this point to be used for a fairly close background.

As one moves even closer to the mountain, more details can be added including some fine brush stippling to suggest the forested foothills.

Rolling Mountains

The rolling mountain ranges of eastern North America are covered with leafy hardwood forests. The Great Smoky Mountains painted on this page (step-by-step) and the following page, are a good example of how these old rounded slopes appear in the distance.

(a)

(b)

(c)

Cobalt Blue plus Payne's Gray, muted with a touch of red-orange. Very pale.

Phthalocyanine Blue plus Sap Green, muted with red-orange.

Same mix as above with more Sap Green added.

① Block in the individual slopes, starting with the most distant one (a). Let each watercolor wash dry before painting the next one.

② Glaze slopes (b) and (c) with the same paint mixtures, using a no. 4 round brush and stippling dabs.

③ When the texturing dabs are dry, glaze a thin wash of ultramarine Blue over slope (c). Closer slopes may be added as seen in the painting on the opposite page, keeping in mind that they will be brighter with slightly more detail.

The apple leaves and young fruit serve as a center of interest for my Smoky Mountain painting. They began as apple leaf prints using Delta Ceramcoat, Medium foliage Green (d). Next I outlined one side of the main veins using Sap Green watercolor and a small detail brush (e). The leaves were glazed with Sap Green/Hooker's Green (f).

Leave the veins pale.

(d)

(e)

(f)

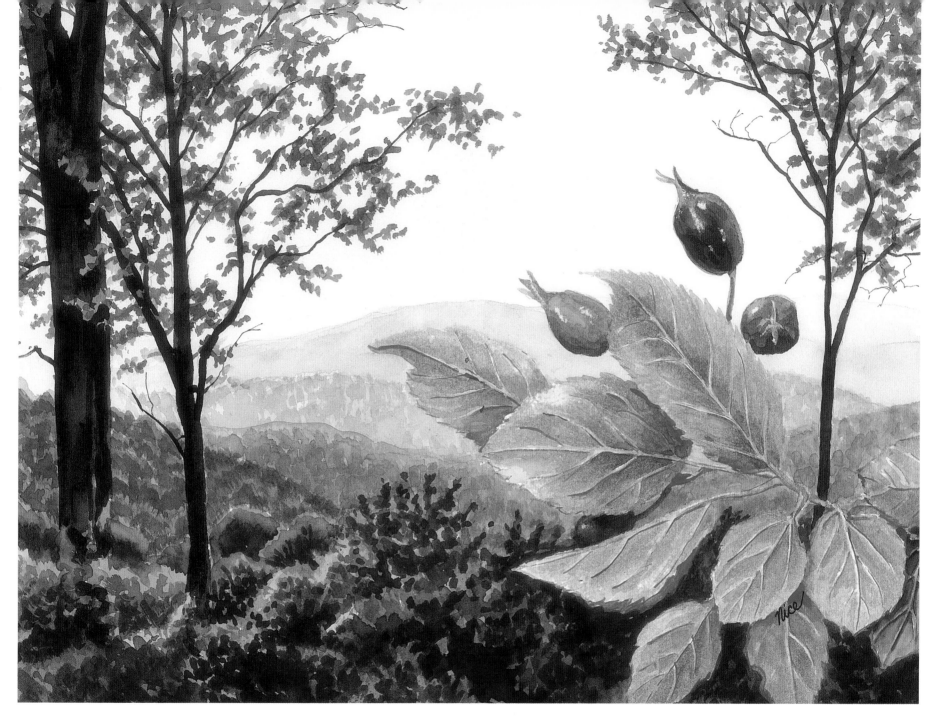

THE PROMISE OF APPLES IN THE SMOKIES
Watercolor with stamped acrylic leaves.

Acrylic Mountains

Painting a mixed media landscape in which the background is acrylic and the foreground is watercolor, pen, and ink, will lend an opaque feeling of strength to the distant mountains and hills. Either tube acrylics or bottled liquid acrylics can be used.

 Black
 Country Blue (Cobalt Blue plus orange)
 Payne's Gray
 Sap Green
 Blue-Green

White
 Beige (Burnt Sienna plus white)
Burnt Sienna

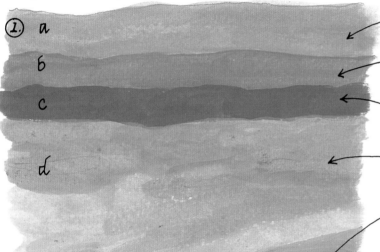

① a → Country Blue plus white

b → Country Blue, Blue-Green plus white

c → Country Blue, Blue-Green and less white

d → Blue-Green plus white

e → Beige with a touch of Cobalt Blue. Streak in few lines of Burnt Sienna/Cobalt Blue plus white.

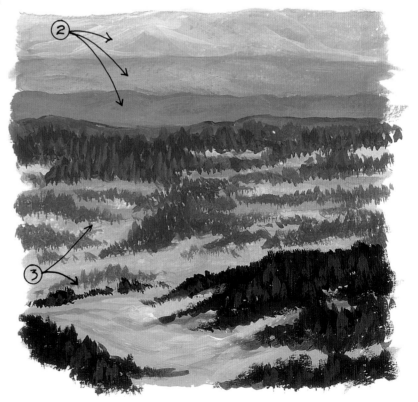

① Base coat the mountain ridges as shown.

② Stroke over ridges a, b and c with white acrylic thinned with water. Don't over blend.

③ Use a round, no. 4 brush to tap stands of trees on ridges d and e. Mix Country Blue, Payne's Gray, Sap Green and just a touch of white for d. Mix Sap Green into Black for e.

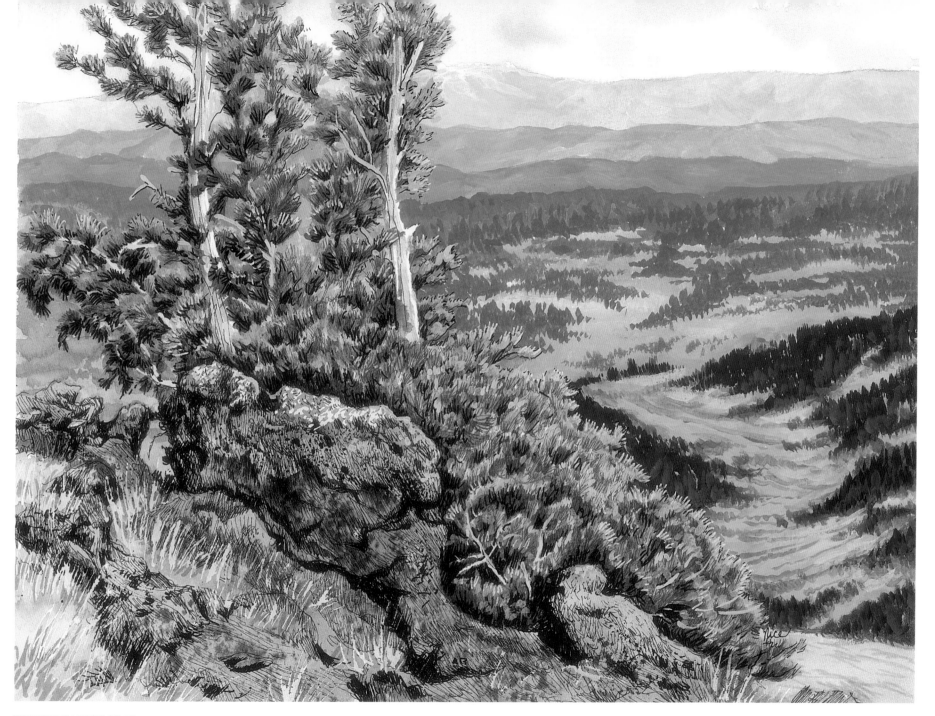

WHERE EAGLES SOAR
Mixed media: the background is acrylic while the foreground is watercolor with pen, ink and acrylic texturing.

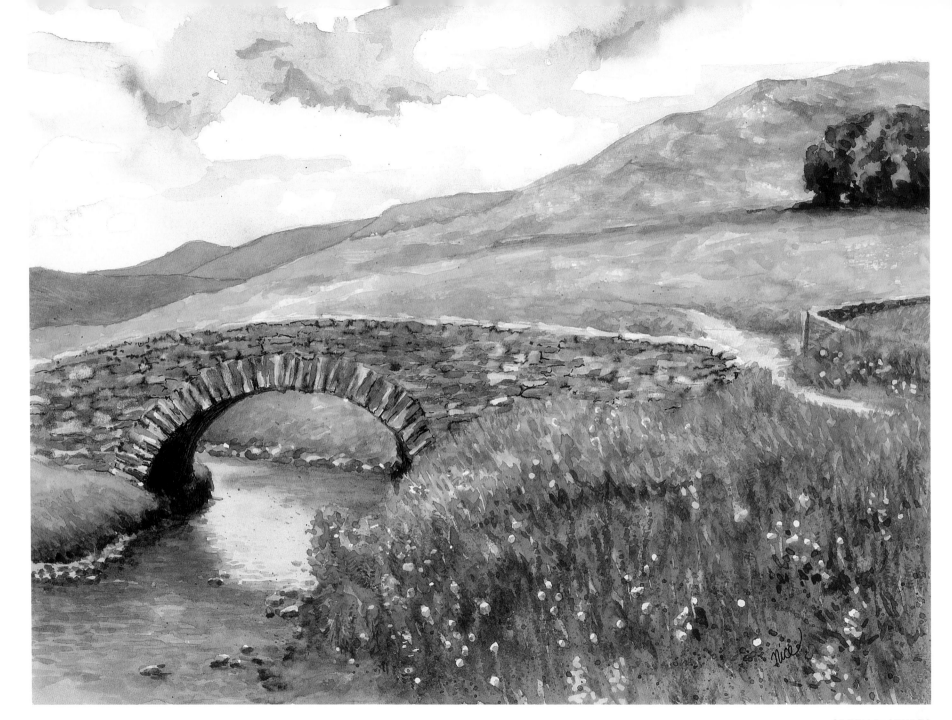

GREEN PASTURES
Watercolor with pen and ink texturing (pen blending) on the stone bridge. Masking and spatter were used to texture the foreground.

Painting Pastoral Hills

Grass green hills appear a deeper, more muted shade of green as they recede into the distance. The atmosphere adds a blue haze, making each consecutive hill less distinct.

Start

② ④ ③ ②

①

The painting on the opposite page began with a wash of watercolor in each of the hill sections as shown at the left. Each section was allowed to dry before the one next to it was painted.

The paint was applied with a no. 4 round brush. A small flat brush would work well for the closest hill.

1. Yellow green- (mix a hint of Phthalocyanine Blue into Lemon Yellow). Dip the brush into Sepia watercolor near the top of the foreground hill. Allow it to run into the yellow green.

Step two

Glaze a thin wash of Cobalt Blue over background hills 2, 3 and 4.

Bare spot

2. Blue green- (Phthalo. Blue plus lemon Yellow), muted with a touch of red.

3. Add more water and a touch of Dioxazine Purple to mixture (2).

4. Add more water and purple to mixture (3).

finish

Prepare several green washes which are slightly darker than the yellow-green used on hill no. 1. Daub the greens randomly across the hill to add color variation and a bit of texture. Do not over-blend the greens together... let the colors remain distinct.

Permanent Green

Permanent Green plus red

Sap Green

Sketching Mesas and Sandstone Formations

Mesa, Spanish for "table", can also be a land formation with steep rock walls and a flat top. Mesas are common in the arid parts of the United States and Mexico. They are rugged, highly textured, and often colorful — very fun to sketch.

The mesa painted to the right was done in three mediums, the most detailed being in the foreground.

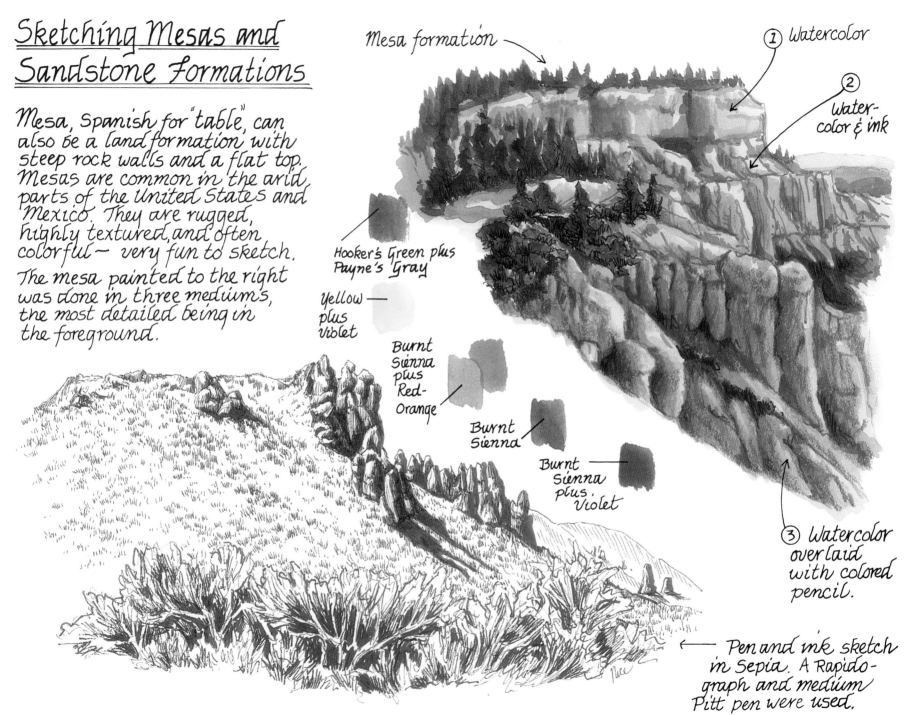

Mesa formation

① Watercolor

② Watercolor & ink

Hooker's Green plus Payne's Gray

Yellow plus Violet

Burnt Sienna plus Red-Orange

Burnt Sienna

Burnt Sienna plus Violet

③ Watercolor overlaid with colored pencil.

Pen and ink sketch in Sepia. A Rapidograph and medium Pitt pen were used.

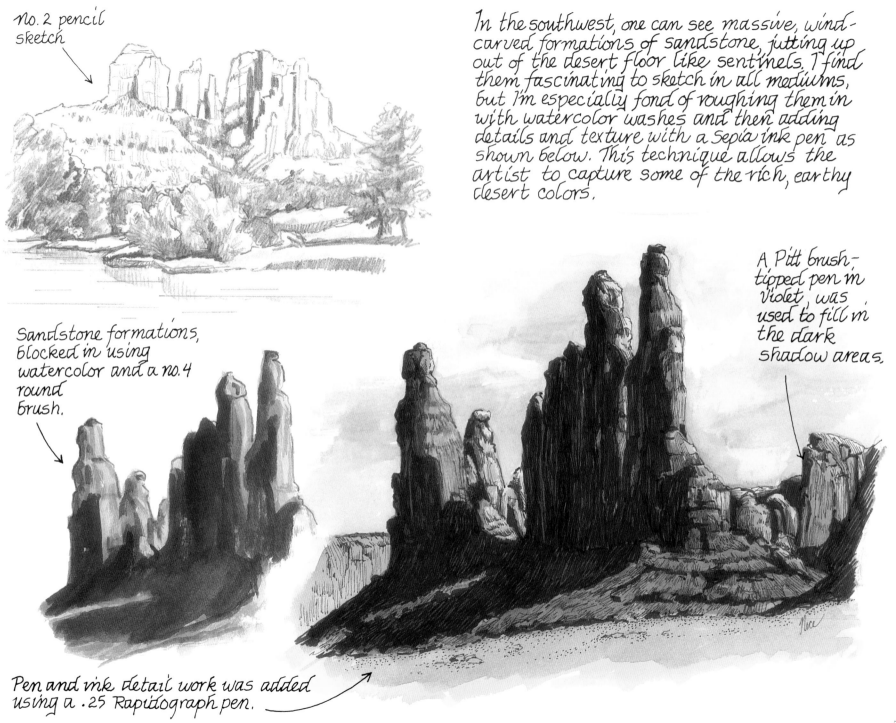

no. 2 pencil sketch

In the southwest, one can see massive, wind-carved formations of sandstone, jutting up out of the desert floor like sentinels. I find them fascinating to sketch in all mediums, but I'm especially fond of roughing them in with watercolor washes and then adding details and texture with a sepia ink pen as shown below. This technique allows the artist to capture some of the rich, earthy desert colors.

A Pitt brush-tipped pen in violet, was used to fill in the dark shadow areas.

Sandstone formations, blocked in using watercolor and a no. 4 round brush.

Pen and ink detail work was added using a .25 Rapidograph pen.

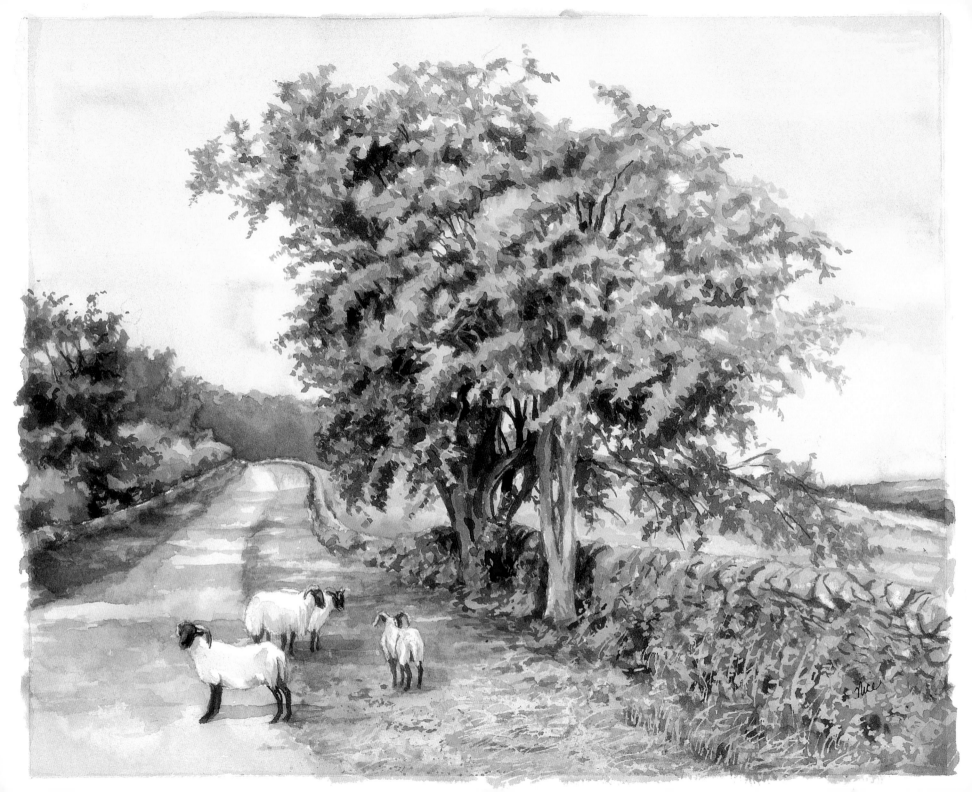

Texturing TREES, TRUNKS and FOLIAGE

With the exception of prairie grasslands and desert rockscapes, one seldom sees a painted landscape without the presence of trees. As part of the foreground, strong trunks and sturdy branches lend bold directional lines to the composition, becoming a key part of the overall design. Leaf patterns contribute a soft, lacy texture to the scene, their cast shadows creating interesting shapes across the ground. In the distance, bands of trees can be used to transcend the horizon, subtly anchoring the sky to the earth. With all their diversity in shape, color and texture, trees are as useful to the landscape artist as flour is to a pastry chef. Therefore, this chapter is dedicated to the creation of trees, using some basic methods and a few wildly spontaneous techniques.

In the painting on the opposite page, entitled *Wandering*, the hawthorne trees fill the center of the composition. The sheep, as part of the focal area, pull the eye to the left and send the viewer down the country road. The tree foliage was stippled into place with the tip of a no. 4 round brush, beginning with the lightest, most delicate yellow-greens and filling the shadowy interior with muted Hooker's Green and Sap Green. I was careful to let plenty of sky patches show through to maintain a light, airy feel in the foliage. The most important part in painting this landscape was to forget pre-conceived ideas of what trees look like, loosen up and have fun.

WANDERING
Watercolor. The tree foliage was stippled on with the tip of a no. 4 round brush.

Bark Textures

One of the best tools for giving the look of reality to tree bark is the pen. By changing the stroke, one can create a great variety of textures. A .25mm nib was used for the fine detail work.

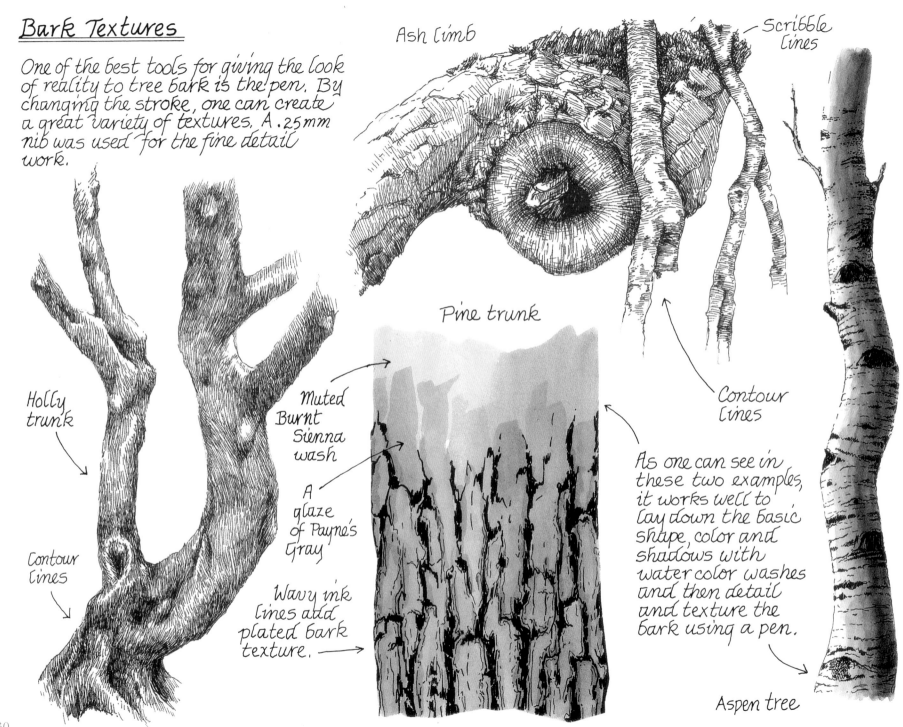

Ash limb

Scribble lines

Holly trunk

Contour lines

Muted Burnt Sienna wash

A glaze of Payne's Gray

Wavy ink lines add plated bark texture.

Pine trunk

Contour lines

As one can see in these two examples, it works well to lay down the basic shape, color and shadows with water color washes and then detail and texture the bark using a pen.

Aspen tree

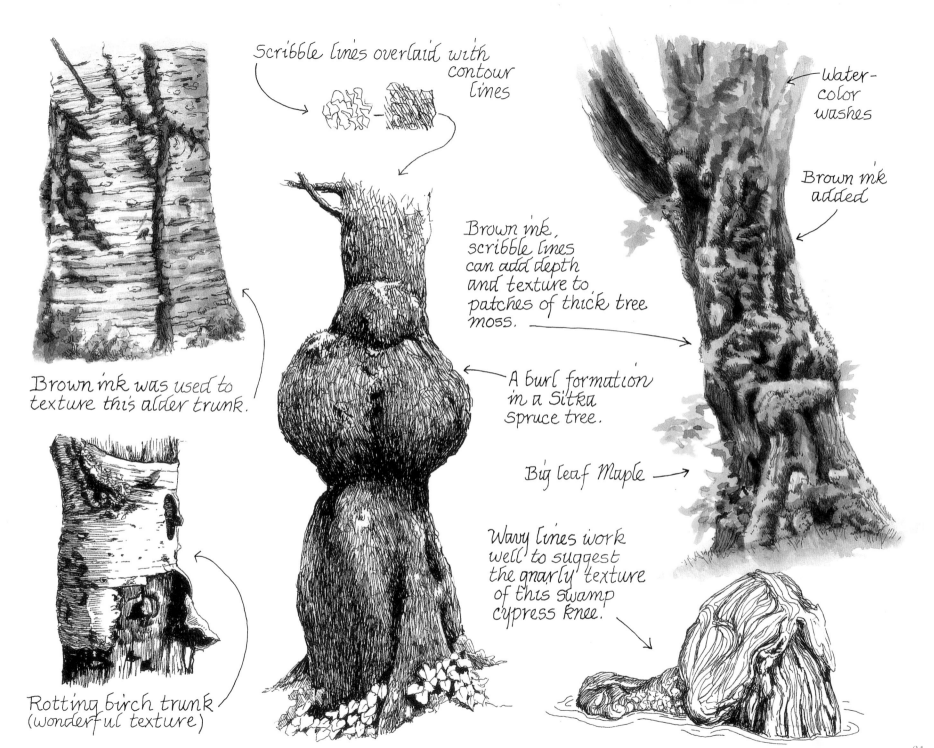

Scribble lines overlaid with contour lines

Brown ink was used to texture this alder trunk.

Rotting birch trunk (wonderful texture)

Brown ink scribble lines can add depth and texture to patches of thick tree moss.

A burl formation in a Sitka Spruce tree.

Wavy lines work well to suggest the gnarly texture of this swamp cypress knee.

Water-color washes

Brown ink added

Big leaf Maple

61

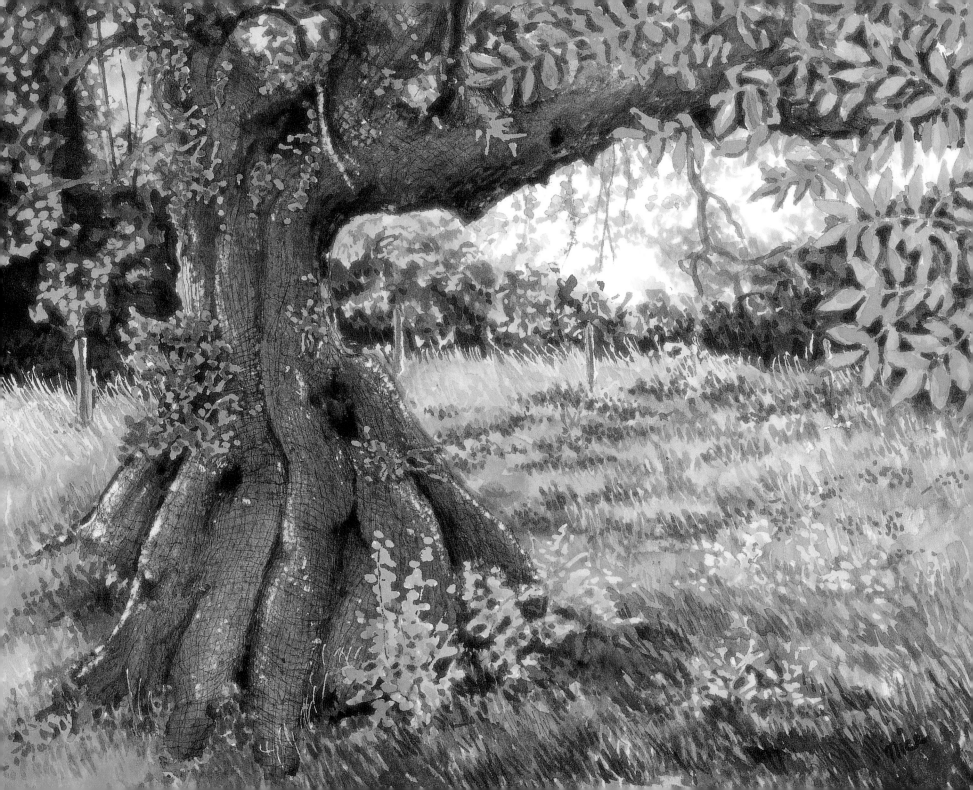

Gauze was used to create the trunk texture in the ANCIENT ASH TREE painting shown on the opposite page. The technique used has four easy steps - - -

① Decide the shape of the trunk and pencil it in lightly

② Use a pale, neutral brown (Sepia) or gray wash and base-coat the trunk. Darker washes may be used to indicate shadows.

This would make a good Dogwood tree.

← Bruising the paper by running a stylus or toothpick through a wet wash is a quick way to texture a trunk.

Juniper tree →

③ When the base wash is dry, cover the trunk with a piece of gauze and stroke another layer of paint onto the trunk through the gauze.

Do not remove the gauze until the paint is dry.

④ Remove the gauze and paint in the fine details.

63

Straw-blown Winter Trees

A fun way to create rugged roots and branches is to herd a small paint puddle randomly across the paper with puffs of air through a straw.

① A paint puddle mix of Burnt Umber and purple

② Puff Puff

1. Begin by placing a small dab of water-color wash on the dry paper surface using a fully loaded round brush. The small gathering of paint will become the base of the branch or root. Make sure the puddle-like dab contains enough moisture to form a raised bead.

2. Place a plastic straw at the base of the paint puddle and blow a puff of air. The paint will travel away from the straw. A gentle flow of air through the straw will cause the paint to move in a single line. A strong puff will scatter the paint into several lines, moving off in different directions. To change the direction of paint flow, blow across the paint bead, coming from a different angle.

The bark on this tree was textured by drawing a stylus over a wet wash surface and bruising the paper.

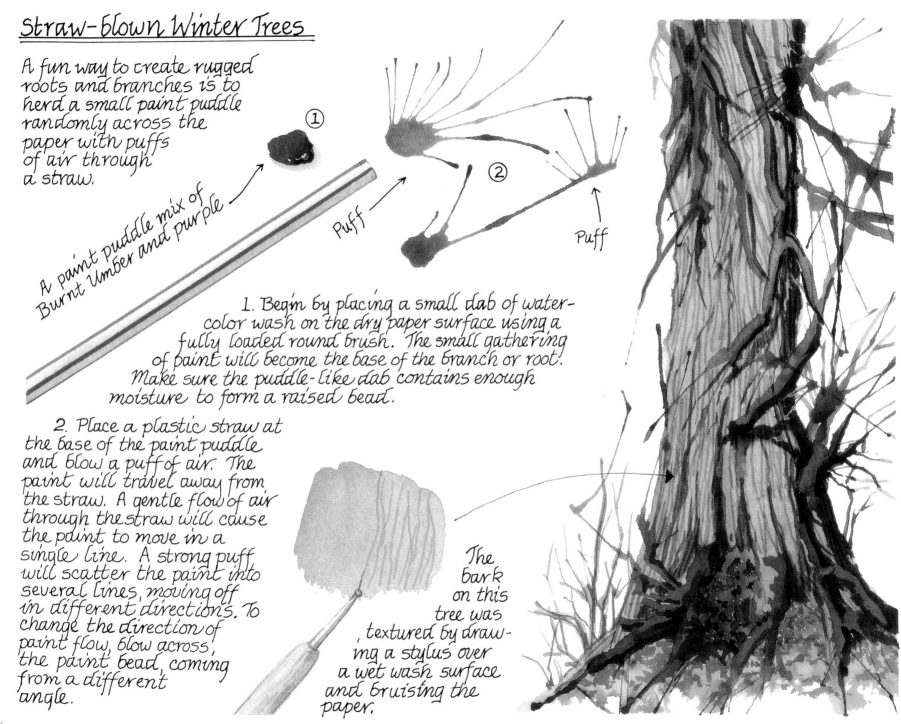

Painting Distant Trees

To create natural looking trees near the horizon, first stroke a pale base color over a pre-moistened surface and let the pigment free-flow skyward.

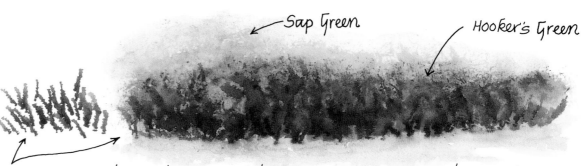

Sap Green

Hooker's Green

Before the first paint layer dries completely, use the tip of a 1/4 inch flat brush to stipple a darker hue along the lower edge of the tree grouping. Let the paint spread.

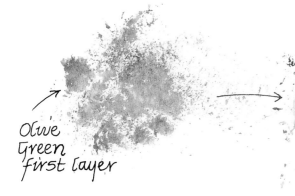

Olive Green first layer

Ⓐ

Second layer is Sap Green.

Ⓑ

Stamping is an effective way of creating distant foliage. If you're working in watercolor, start with the palest color and add the darker layers one at a time. Remember to allow some of each stamped layer to show through, giving the foliage a thick, three-dimensional effect. Stamping over colors that are not quite dry will give the hues a chance to mingle. For a crisp effect, stamp each layer on a dry surface.

Tree (A) was stamped using a wad of dry tree moss. It's fun to experiment with natural tools, especially if you're painting out-of-doors. A damp sea sponge was used to stamp the foliage of tree (B). For basic stamping techniques turn to page 20.

Brush Stippled Foliage

① Begin with a light pencil outline indicating the trunk, main limbs, and the foliage clumps on the near side of the tree.

Oak tree

② Select the lightest color to appear in the sunlit areas of foliage and loosely block them in.

Mixture of Cadmium Red, Lt. and Cadmium Orange. (Autumn coloration.)

③ Use the tip of a no. 4 round brush to stipple in the darker inner foliage and to paint the limbs and trunk.

Red orange darkened with Phthalo Blue.

④ Stipple on a second layer of color to deepen shadow areas and to suggest texture. Maintain a delicate touch, allowing the first layer to show through.

Tap in a few individual leaves.

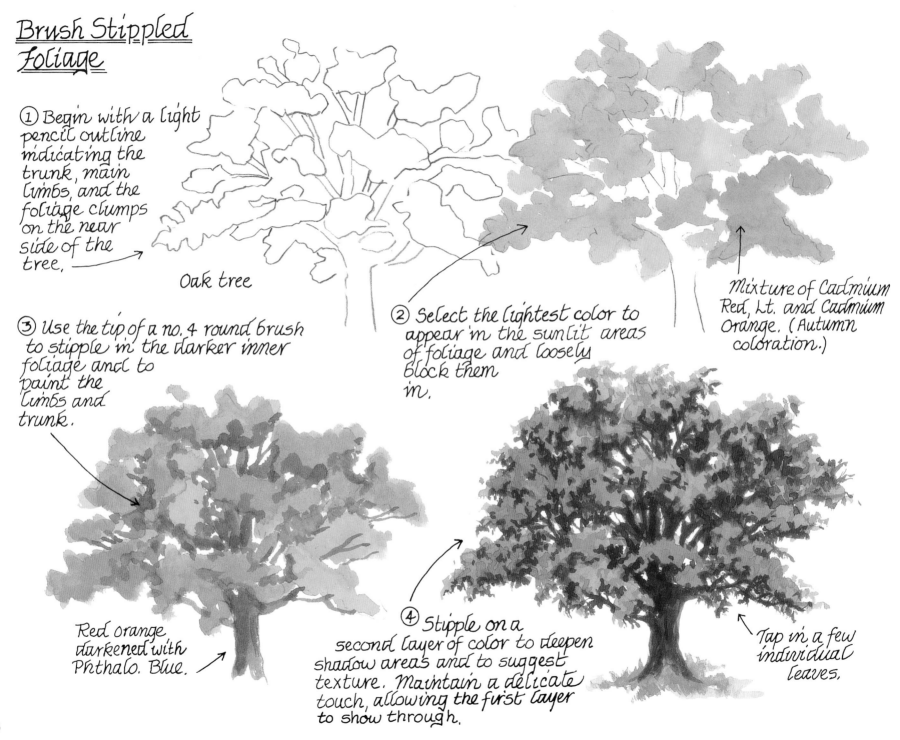

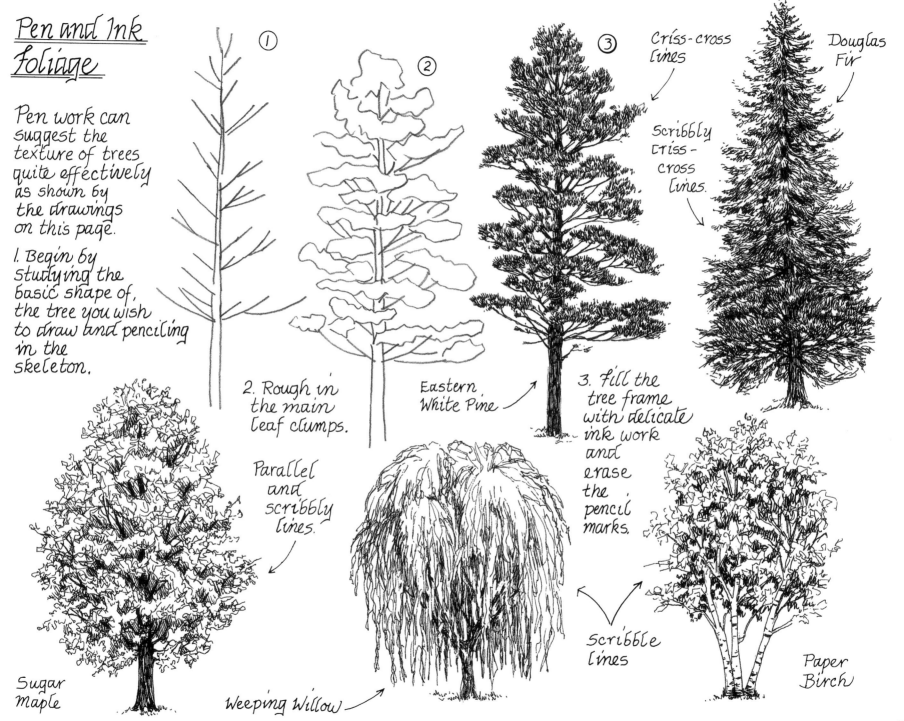

Pen and Ink Foliage

Pen work can suggest the texture of trees quite effectively as shown by the drawings on this page.

1. Begin by studying the basic shape of the tree you wish to draw and penciling in the skeleton.

① ②

2. Rough in the main leaf clumps.

Parallel and scribbly lines.

③

Criss-cross lines

Scribbly criss-cross lines.

Douglas Fir

Eastern White Pine

3. Fill the tree frame with delicate ink work and erase the pencil marks.

Scribble lines

Sugar Maple

Weeping Willow

Paper Birch

Creating Bright and Airy Foliage

Masking fluid was indispensable when it came to painting the delicate alder leaves in the painting on the opposite page. Here are the steps I used...

1. Masquepen fluid (blue) was dotted on to protect the light foliage and flower areas while the background was roughed in. Salt texturing was used to add interest and variety to the darkest areas (see page 26).

2. Light Olive Green / Sap Green leaves were stippled sparingly over and around the masked alder foliage, using a no. 4 round brush. Tree trunks were painted, and the foreground was detailed.

3. Masking was removed to reveal white leaf areas.

4. In the finished painting - MORNING MIST AND AUTUMN ALDERS (opposite page), the tree foliage is painted pale Lemon Yellow / Olive Green. The fallen leaves on the road help to balance the color.

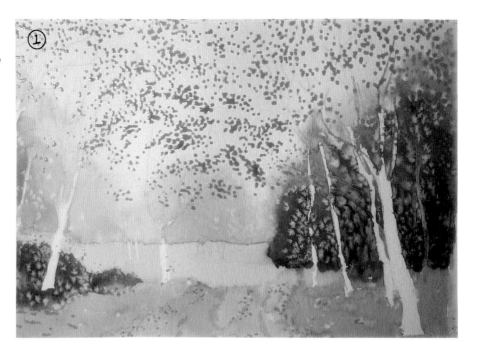

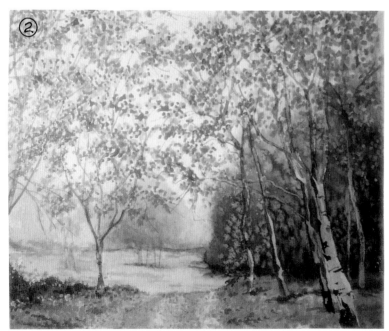

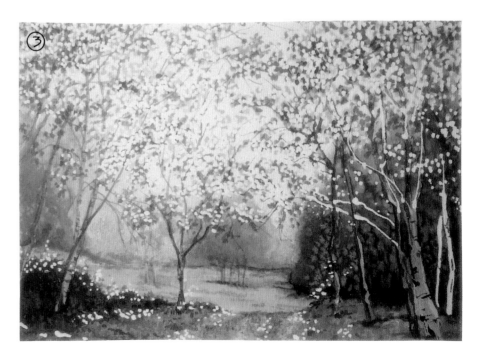

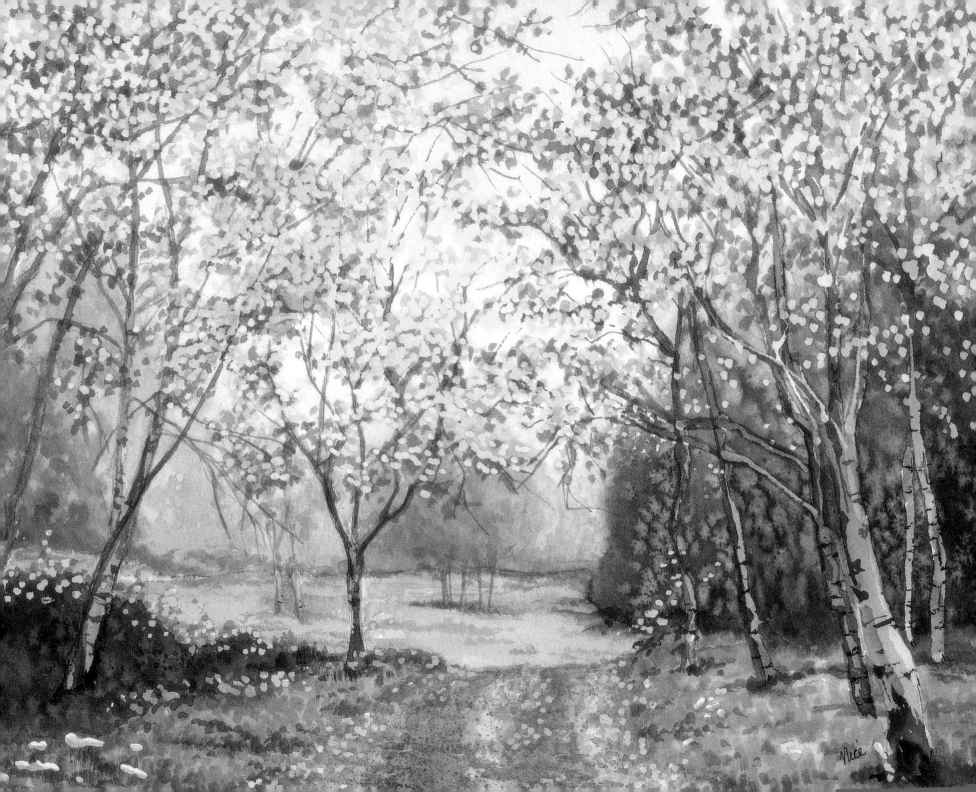

Creating a Thrown-Paint Forest Landscape

Here is the scene I've chosen to paint. It has some good shapes and strong value contrast between the dark branches and light sky background. By adding some light foliage areas, it will make a pleasing composition.

A quick thumb nail sketch helps me plan out the painting.

— Blue: sky areas to be masked out.

Preparation: I sketched the scene onto a piece of 140-lb. watercolor paper using light pencil marks. The edges of the paper were taped to a backing board. This keeps the paper from curling under when wet, but allows the surface to be turned and tilted. I used masking fluid to mask the areas as indicated.

— Brown: trunk areas to be masked out.

Green: free-flow foliage areas.

The thrown-paint, free-flow technique:

Foliage created from thrown paint is unpredictable, messy and fun!

Begin by mixing up several paint puddles on your palette. They should be the consistency of cream ... rich in pigment. Use a large round brush or mop brush to dribble, drip or forcefully fling the paint onto the paper in the areas where you wish to create foliage.
The surface of the watercolor paper should be dry, so that the resulting spots, splats and splatters remain in crisp, wet mounds. _____

Sap Green

Yellow Green

Sepia

Before the splotches of paint have a chance to dry, spray the area lightly with water from a squirt bottle. Old glass cleaner spray bottles work well for this. Look for a spray head that produces a variety of drop sizes. Fine drops cause the paint to flow into a lacy design. Larger drops cause the pigment to run together and fill in more solidly, mingling the colors. Don't over-do the spray. You don't want puddles to form. Wick away accumulated fluid with a tissue. Control the direction of flow by tilting the backing board.
Here is how my painting turned out.

As soon as the free-flow foliage is completely dry, the masking can be rubbed away with a piece of masking tape wrapped around the finger, sticky side out.

The photo to the right shows the next few steps I took with the painting.

(a) I roughed in the dark trunk areas using Sepia, Burnt Umber and dirty palette grays.

(b) I stroked pale washes of Sepia, Burnt Umber and muted Yellow Green into the foreground.

(c) Masking fluid was used to preserve the white snow areas of the Mountain (shown in blue).

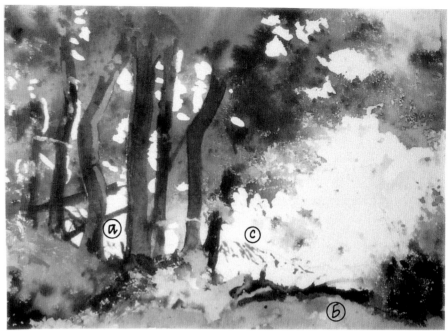

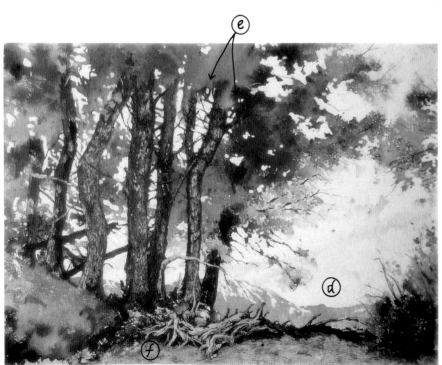

In the photo to the left, the progress continues.

(d) The mountain range is painted a muted Cobalt Blue (a touch of orange was added). The sky was also streaked with a faint Cobalt Blue wash. When dry, the masking was removed.

(e) Aquacover liquid Watercolor Paper was used to reclaim additional sky areas in the tree branches (see page 24).

(f) Black pen and ink texturing, size 35mm. nib, was added to the tree trunks, limbs, and the piece of weathered wood in the foreground. Brown ink was used to scribble texture into the ground cover.

Opposite page: A bit of round brush detailing completes the TIMBERLINE RIDGE painting.

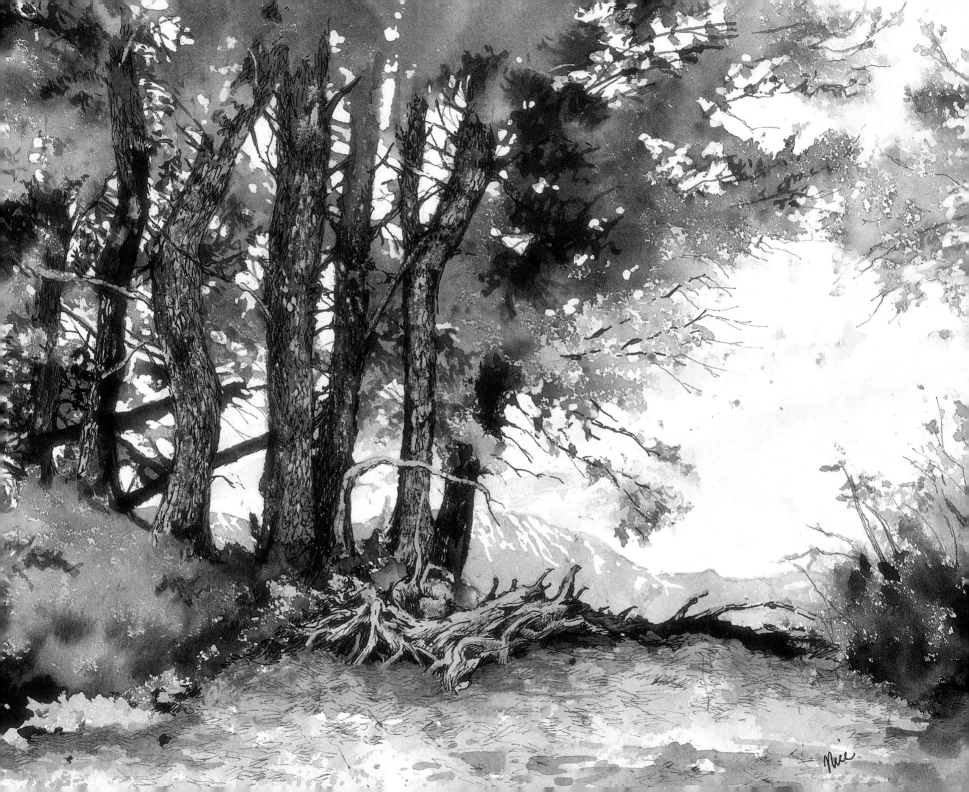

Depicting Thick Foliage Areas ~

This watercolor and ink technique is not quick and easy, but it is effective.

① Pencil in the foreground trees and draw loose scribbly shapes to represent close-up foliage. Outline the leaf shapes with a fine ink line and paint them in using several shades of Sap or Permanent Green.

② Use a no. 4 round brush to dab or stipple a variety of muted greens, browns and grays into the background. Work on a damp surface.

③ Darken and further define the background by adding solidly inked areas, and parallel and scribbly ink lines. This ink detail work will create interesting shadow shapes, popping the leaves forward.

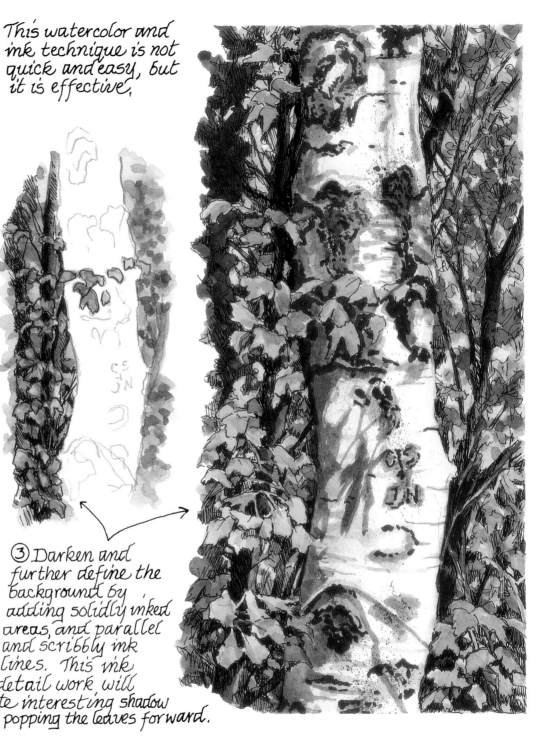

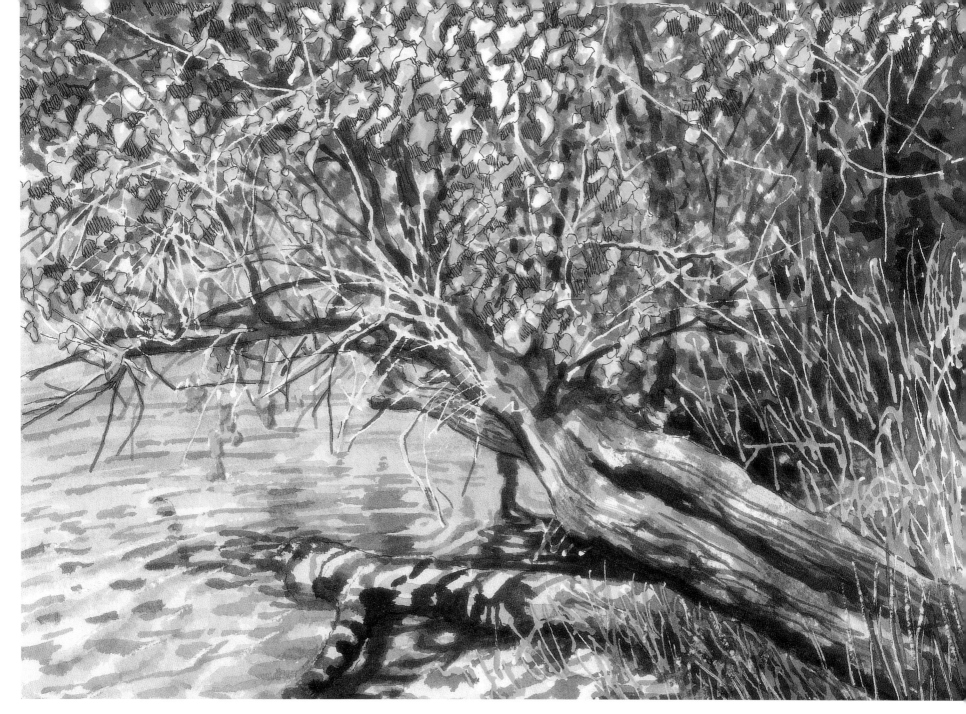

SHADY SPOT BY THE RIVER
A combination of pen work, round brush stippling, and masking were used to create the foliage in this watercolor painting.

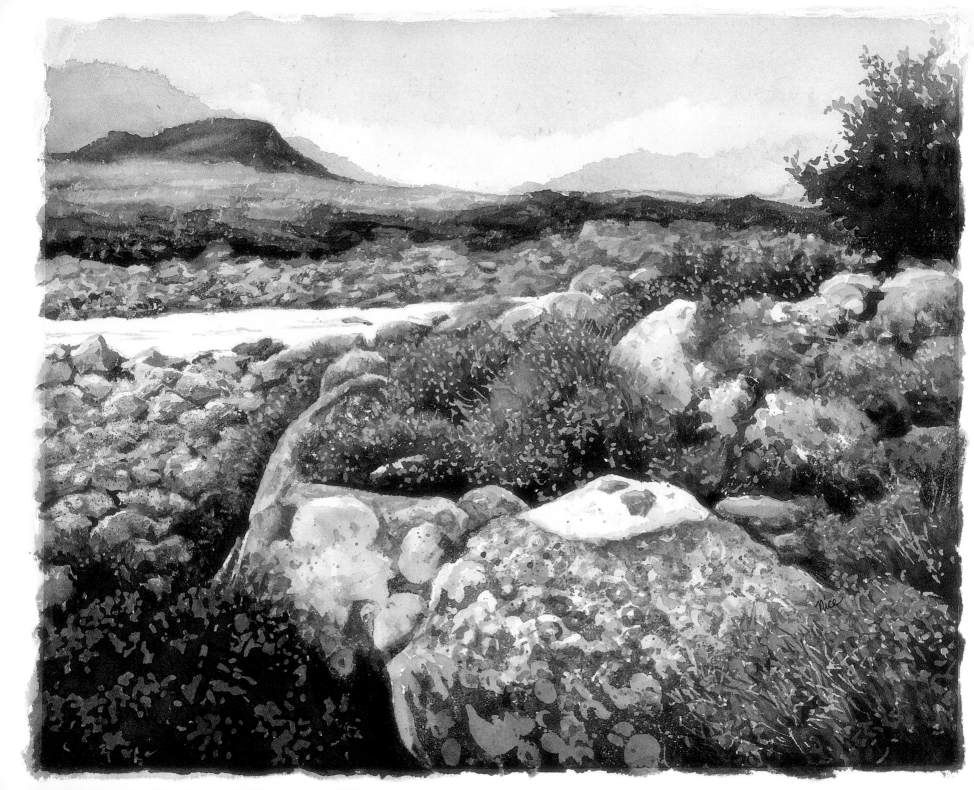

5 RUGGED and GRITTY
Rocks Gravel

If rocks are the building blocks of the earth, then it stands to reason that painting a few rocks in a landscape will add strength and a touch of reality to the composition. However, portraying them is not always easy. They are not just chunky shapes wrapped in earth tones. Rocks need texture to be true to form. Even smooth, water-worn stones have a unique surface that can be represented in paint. This chapter will introduce you to some fun techniques that will enable you to create rocks with character and stretches of gravel that appear so real that you'll want to step on them just to hear the crunch and clatter beneath your feet.

Consider the painting on the facing page. Stones of all shapes and sizes make up a good portion of the composition. The distant rocks were not individually drawn and painted. I used contrasting values to suggest their contours and let the viewer's mind give them their form. In the foreground, I relied heavily on masking fluid to develop the pale, crisp-edged lichen colonies growing on the boulders and the bright heather blossoms springing from the rocky crevices. To give the rough rocks further character, I used glazing techniques, spatter, alcohol drops and even a hollow dahlia stem to stamp in the crusty ochre lichen rings. The best part of it all was that I enjoyed doing it!

LICHEN AND HEATHER
Watercolor textured with a variety of techniques including glazing, spatter, alcohol droplets, and the hollow stem of a dahlia.

Painting a Simple Rock

As a stone endures centuries of abuse from water, wind and pressure, it takes on a distinct character. It may be worn smooth by the tumbling action of a stream or become cracked, chipped, and roughened. When an artist fails to reveal the textural quality of the stone he paints, it may look more like a lump of dough than a stone. These steps will help you get past the lump stage...

① Pencil in some irregular rock shapes. Remember to flatten the bottom if it sinks into the earth.

② Base coat the rocks with a thin wash of watercolor to seal the paper. Select the lightest hue you see in the stone, excluding white. Let it dry!

This color is a mix of Burnt Sienna and Rose, muted with Sap Green.

③ Create contour shadows by blending a darker mix (add more green) into the areas obscured from the sun. Keep in mind that softly blended value changes suggest rounded contours. When stage three is complete, you will have a nicely contoured "lump."

④ Abrupt value changes suggest angular planes and distinctly-cornered edges. To make the rock look roughened and worn, add some hard-edged shadow areas. These cracked, chipped and broken areas transform the lump of bread dough into a hard, unpolished stone.

⑤ Blot a loaded flat brush, gently splay the hairs apart and texture the stone with a bit of drybrushing (see page 15).

⑥ Use a razor to scrape in some highlights.

A bit of spatter.

Cast shadows

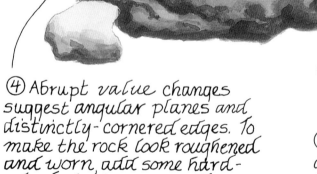

Painting a Pitted Rock

The worn piece of cindery basalt (lava rock) in the foreground of the photo is a good example of a pitted rock.

To paint a similar rock, follow steps one through four on the previous page. Use the tip of a no. 4 round brush to add stippled splotch marks to the surface.

Mask out the weeds and rushes.

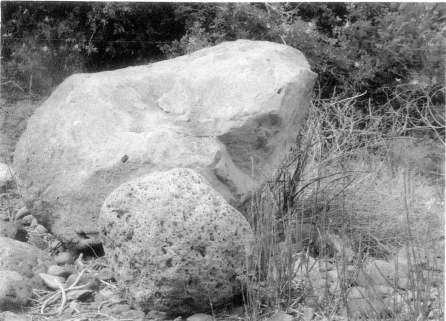

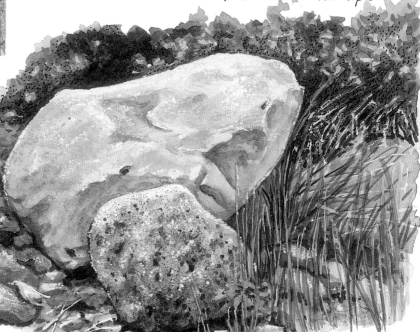

Create pits in the rock by adding brush spatter and brown ink detailing.

Razor scrape

Rough in the back-ground and re-move the masking.

finished rockscape.

79

Sandstone

This common sedimentary material can be seen in beach bluffs, desert, formations, prairie floodplains and in areas which were once covered by the sea. The warm colored stone appears smooth at a distance and gritty up close.

Here are six different techniques for creating the look of Sandstone. The colors used were red-orange and violet mixed together to form several varieties of earthy brown-violet.

Bruise texture into a wet wash using a stylus or, a tooth pick.

Sprinkle sand into a very wet wash and let it remain until the paint is dry.

This is brown ink penwork, overlaid with watercolor wash.

The two color areas were allowed to charge together at the border.

Splayed brush, dry-brushing was worked over a basecoat of color.

This gritty texture was achieved by applying layers of spatter, some on a dry surface and some on a damp. A sheet of paper with a rock-shaped cut-out protected the edges.

In the DESERT SANDSTONE painting on the following page, I used a combination of all the techniques shown here to paint the rocks in the foreground. The sandstone formations in the background were created using multiple layers of paint. Some of the layers were blended at the edges, but most of the glazes were laid down crisp and distinct to suggest rugged contours. Just for fun, I blew the pine limbs into craggy configurations using a soda straw to direct the paint flow.

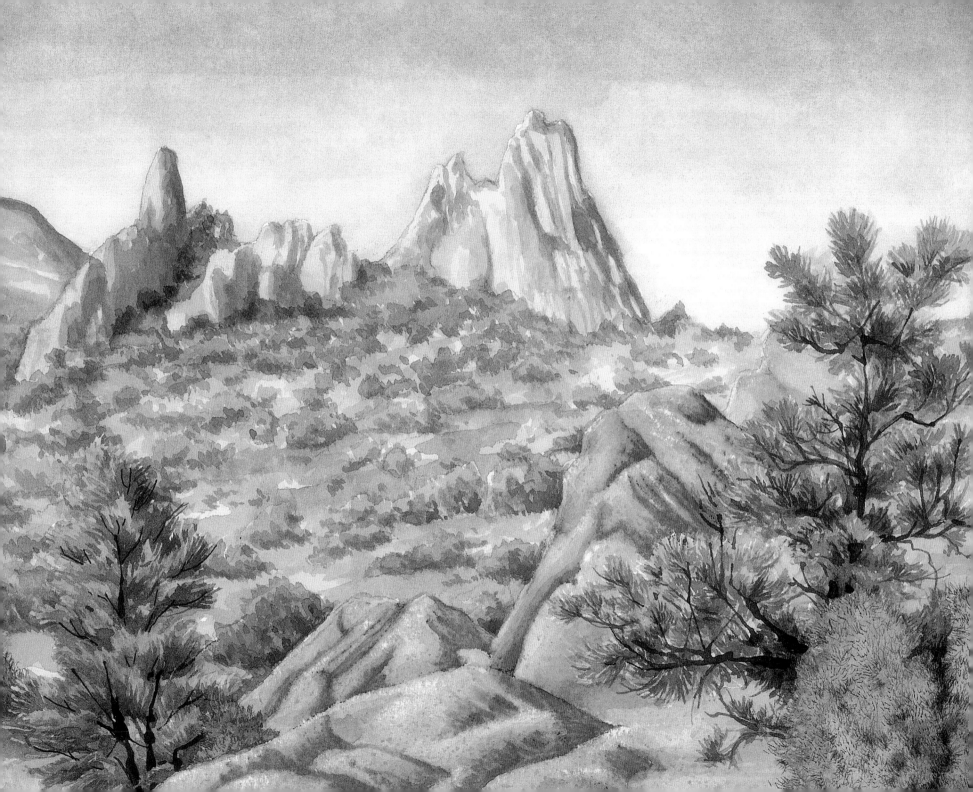

Fun Stone Walls

Walls which are meant to endure are usually constructed with mortar between the stones like the two examples on the top of this page. The mortar I used was a pale wash of Payne's Gray watercolor, laid down first and allowed to dry.

The stones on this wall were brushed on using earthy-hued watercolors and a small flat brush.

Base wash

Spatter

Sap Green

Blot each stone with a tissue after stroking on the paint. When dry, add contour and cast shadows with a round brush.

Stippled pen work and spatter.

The stones in this wall were printed with bits of orange peel (see page 20).

Shadows were painted on the lower parts of the rocks, and cast shadows were added below the stones.

Farmers often created dry-stacked stone walls with the rocks they found in their fields. I used an impressed plastic wrap technique to paint the one shown below (see page 23).

Payne's Gray and Sepia mix.

A very wet wash was applied.

A piece of plastic wrap was scrunched into accordion folds, placed into the wet wash and left in place until dry.

Acrylic Grass

A black ink and pen were used to fill in the shadows between the stones. Highlights were scraped in with a razor.

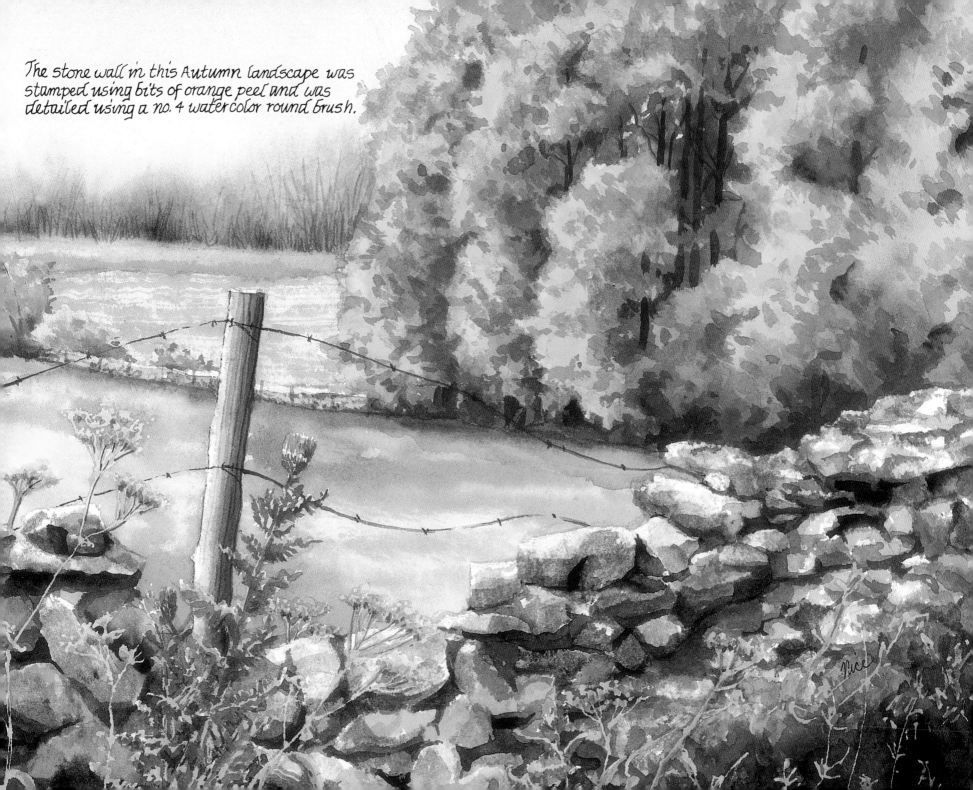

The stone wall in this Autumn landscape was
stamped using bits of orange peel and was
detailed using a no. 4 watercolor round brush.

The Texture of Sand and Wet, Tumbled Stones

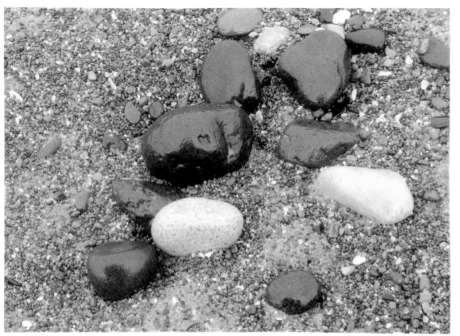

Begin by making a spatter screen. Cut a four inch (10cm) square out of fine wire window mesh. Bind the edges with duct tape, foil or metal sheeting. Set it aside for use later on.

① Draw and mask out the rocks. Use a coarse hobby brush or toothbrush and your finger to spatter masking fluid across the sand area. (See page 17.)

masked areas

Let it dry completely!

② Brush a flat wash of Burnt Umber/ Yellow Ochre horizontally across the rocks and sand. Let it dry.

Pale wash

③ Flick more masking fluid horizontally across the wash layer. Let it dry.

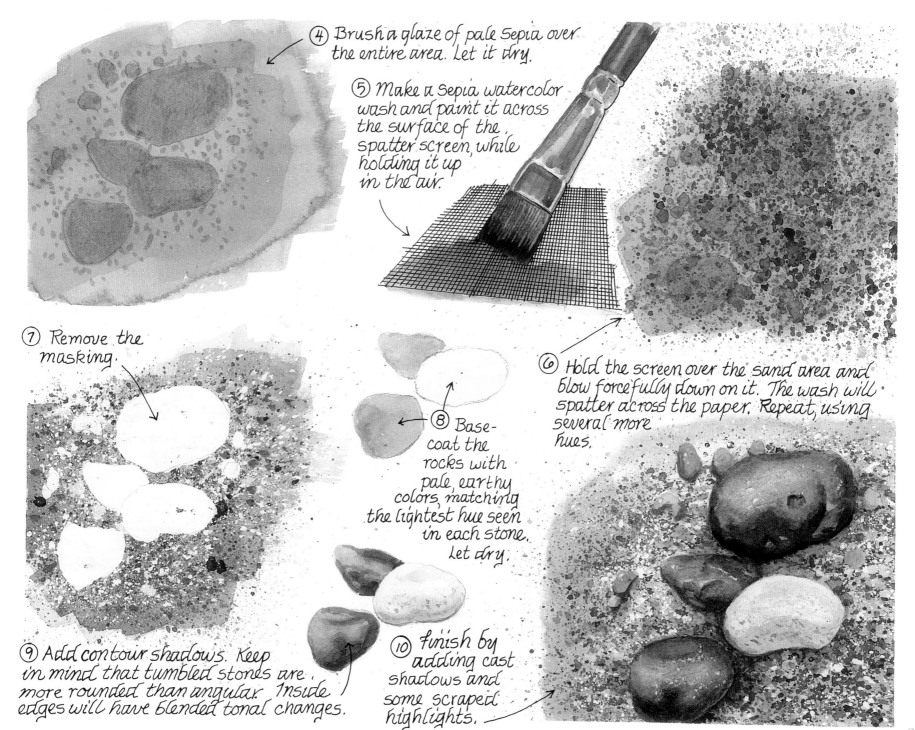

④ Brush a glaze of pale Sepia over the entire area. Let it dry.

⑤ Make a Sepia watercolor wash and paint it across the surface of the spatter screen, while holding it up in the air.

⑥ Hold the screen over the sand area and blow forcefully down on it. The wash will spatter across the paper. Repeat, using several more hues.

⑦ Remove the masking.

⑧ Base-coat the rocks with pale, earthy colors, matching the lightest hue seen in each stone. Let dry.

⑨ Add contour shadows. Keep in mind that tumbled stones are more rounded than angular. Inside edges will have blended tonal changes.

⑩ Finish by adding cast shadows and some scraped highlights.

Sponge Print Gravel

When your landscape calls for an expanse of gravelly ground, you could paint it in pebble by pebble, which is not only tedious, but can have a repetitive, unnatural appearance ··· or you can use a kitchen sponge to stamp the pebbles in place. Here is how it's done, step by step.

① Lay down a pale, earth tone watercolor or acrylic wash in the area where the gravel will go. I used Burnt Umber for the example. Let it dry.

② Moisten a kitchen sponge and squeeze out the excess water. Paint the surface of the sponge with a dark color. I used a mix of Burnt Umber and Sepia watercolor. Acrylic will also work.

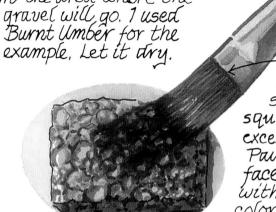

③ Press the painted side of the sponge gently to the paper. It should leave a crisp print. Rotate the sponge direction to vary the pattern.

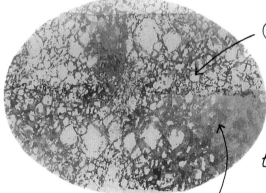

Pressing too hard will blur the image.

④ Use an ink pen or small round detail brush to darken the deep shadow areas below and between a few of the light colored shapes. Pebbles will take shape.

⑤ Tint a few of the pebble shapes using earth tone glazes.

⑥ Add shadows to give the larger gravel pieces a three-dimensional look.

⑦ Flick on some fine spatter and the gravelly ground cover is complete.

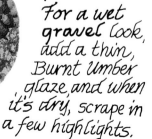

For a wet gravel look, add a thin, Burnt Umber glaze, and when it's dry, scrape in a few highlights.

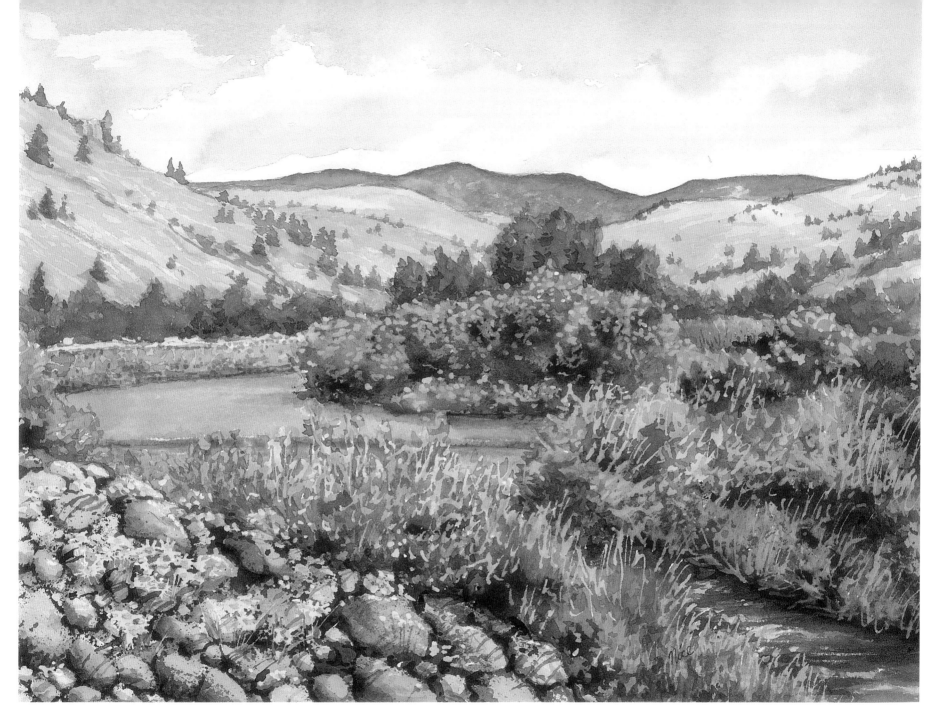

WARM SPRINGS
The rocks in the foreground were created using a car washing sponge with large irregular holes. The flowers were masked out before the sponge pattern was printed on the watercolor paper.

Lichen Textures

Lichen is a type of fungus which is often seen clinging to rocks, providing both color and texture. The rock in the photo below is covered with a crust lichen.

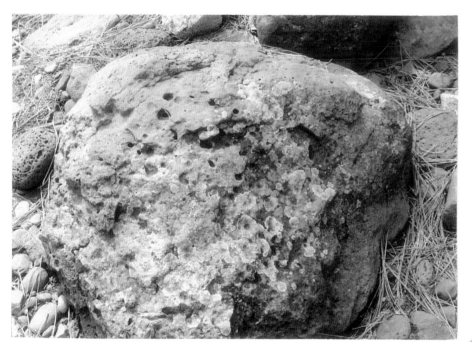

Burnt Umber plus violet

Sepia

① To duplicate the lichen texture, I began with a wash of varied browns.

While the wash was still moist, I spattered isopropyl alcohol drops into it.

Alcohol drops form pale rings in a moist wash.

③ Add shading with a small round brush and Sepia watercolor paint.

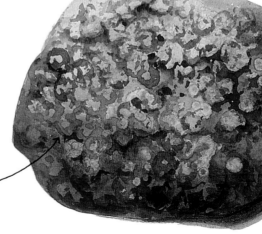

② Use a hollow twig or sturdy plant stalk to stamp sap green rings onto the rock. I used the end of a dahlia stem.

Pen and Ink Texturing

Ink work lends itself well to enhancing the various textures and characters of stone. As seen in these sketches, it is effective used alone or can be combined with washes of acrylic or watercolor to add a touch of realism.

Wind-weathered, sand blasted stones depicted with a .25 mm. nib, stippling, and patience.

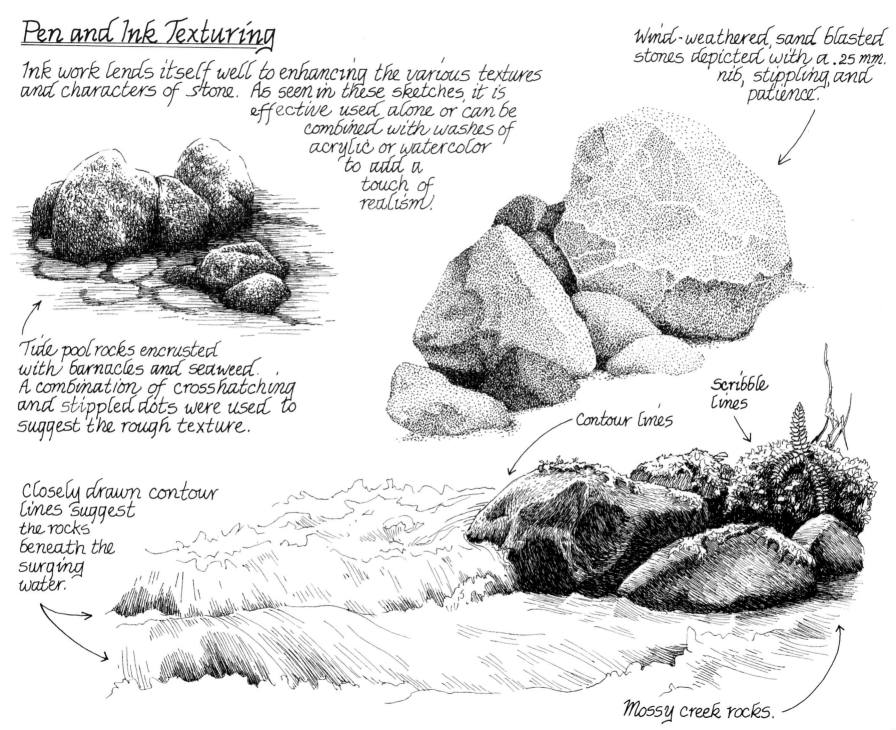

Tide pool rocks encrusted with barnacles and seaweed. A combination of crosshatching and stippled dots were used to suggest the rough texture.

Closely drawn contour lines suggest the rocks beneath the surging water.

Contour lines

Scribble lines

Mossy creek rocks.

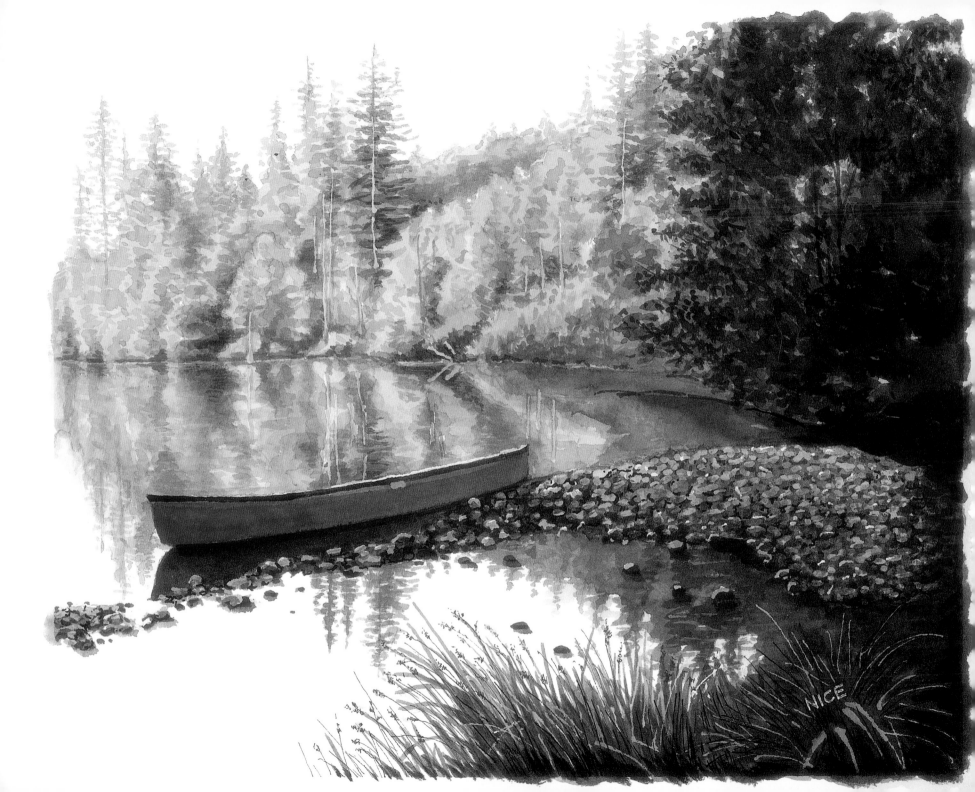

6 TRANSPARENT *Textures* for RIVERS, FALLS and LAKES

Clear, pure water, babbling merrily over a gathering of polished creek stones, is the essence of transparent beauty. It provides a cadence of primeval music for the ears and a cool caress for the fingertips. The artist's eye sees a fluid dance of color, light play and motion that begs to be painted, but how does one capture the crystal clarity with a brush? How does one portray the dimension and movement of a nearly invisible element? The answer is simple. One does not pencil, ink, or paint a transparent substance. Instead, the artist suggests its form and flow by depicting the reflections and highlights bouncing off its surface and the distorted shapes and colors that shine through it.

Study the *Kwa Nee Sum Lake* watercolor painting on the opposite page. Note how the surface of the water is defined by the reflection of the sky and forest. The slight movement of the water is revealed by the rippled images. For step-by-step directions on how this painting was rendered, and some creative techniques for suggesting riffles, waves and whitewater, turn the page and wade into the chapter. The water is fine!

KWA NEE SUM LAKE
Watercolor with pen and ink detailing.

Still Water Reflections

Pure water has no color. The hues we see in still bodies of water are most often the result of reflected color. The water surface catches the shapes and colors of objects which are overhead or nearby, and bounces their images to the viewer. When the water is still, deep and pure, and the sun is shining strongly overhead, the colors in the reflection may appear more intense. Study photo no. 1. See how much more blue the sky is in the reflection. Also, notice that if an invisible plumb line were dropped from one of the curved tree trunks it would line up with the same spot in its reflection.

①

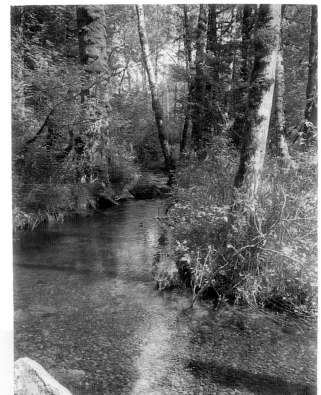

②

vertical, parallel ink lines.

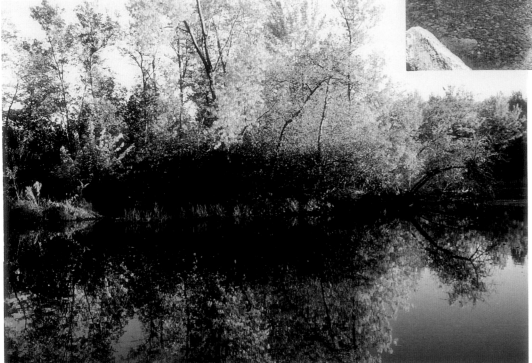

In shallow bodies of clear water, much of the color we see comes from the substratum. In photo no. 2, you can see both the shape and hue of the rocks beneath the water. Also, notice that the dark shadows cast from the tree trunks lay across the creek bed and the sky reflections dance across the surface of the water. The reflections of the sky and forest vegetation are slightly rippled because the water is gently moving. The more turbulent the water is, the more distorted the reflected images become.

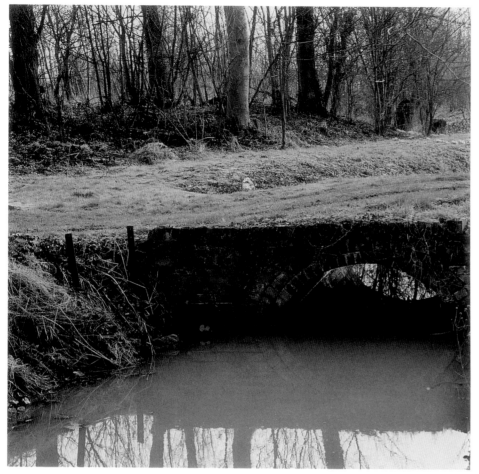

③ When a body of water is murky with algae, mud or other contamimants it takes on the color of the matter it carries. Reflections will appear dull, as if viewed through a dirty window. The pond in photo no. 3 is heavy with silt due to heavy spring rains. The reflections of the bridge and background trees are tinted brown by the muddy water. The overcast sky also effects the brightness of the reflected hues.

Bright afternoon sunlight

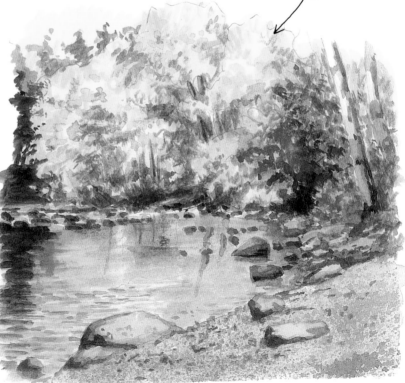

The water reflection study to the right was painted with watercolor washes, then detailed with colored pencil. The stretch of the river depicted was smooth on the surface, but deep and fast moving below. The overhead light was strong. The resulting reflections were brightly colored, but the images were blurred. Near the shore, where the water bounced off the rocks, the image broke into rippled horizontal lines, reflecting both the distant trees and the sky, directly overhead.

These are the steps I took while painting the Kwa Nee Sum Lake Landscape, page 90. In the reference photo below, note the hazy morning light which affected the clarity of the water reflections.

1. The highlight areas, shown in blue, were masked out.

2. The palest colors in the forest and upper water reflection areas were blocked in using watercolor washes over a damp surface and horizontal strokes. The sky and sky reflection areas are left paper white. Mixtures of Lemon Yellow and Sap Green were muted with a touch of Quinacridone Rose to create the various green hues. ⎯⎯⎯

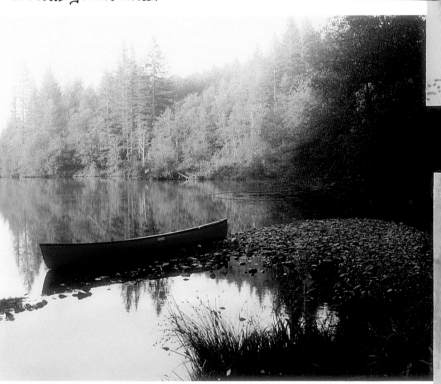

A mix of Hunter's Green and Payne's Gray was used to paint the shaded trees. ⎯⎯⎯

3. The first washes were deepened and detailed using glazes of the same green mixtures. Foreground reflections were added in the shallow water. These are distorted by water ripples lapping the shore. ⎯⎯⎯

4. The trees and their reflections were detailed further using slightly darker green mixtures. The colors were glazed over a dry surface using a no. 4 round brush. Stippling with the brush tip produced leafy textures. The reflection strokes were applied in a horizontal direction and blended at the edges to soften their appearance.

The red canoe is the focal point of the composition. The color I used to paint it is a mixture of Rose and Burnt Sienna, darkened with Sap Green. The color mix applied to the reflection was deepened with the addition of Dioxazine purple. To help balance the red of the canoe, reddish brown shades will be used in the gravel, tree trunks and foreground grasses.

5. The masking was removed from the upper part of the landscape and the tree trunks and their reflections were painted a watered-down version of the canoe color.

The gravel bank picks up the colors used in the rest of the scene, plus Payne's Gray. I used layered masking techniques, spatter and a little pen and ink work to give it texture.

The last to be painted were the grassy reeds and sedges. I stroked in the palest stems first, working towards the dark Hunter Green / Payne's Gray patches. After they were dry, I removed the masking and painted the revealed grass blades Sap Green. Sepia pen work detailed the seed heads on the Burnt Sienna stems.

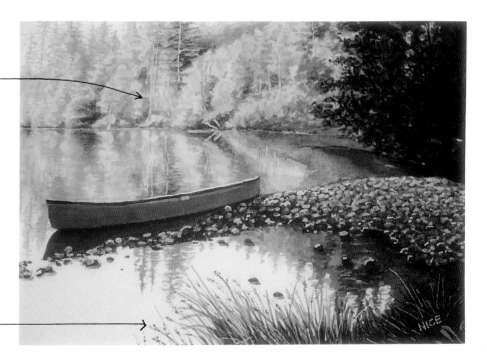

Painting Water Ripples

When water is disturbed or moved along by wind or current, it is pushed up into undulating peaks and valleys. The sky and other bright overhead reflections glint off the peaks of each ripple, while the darker water hues spread themselves into the troughs of the ripples. In the photo below, notice how the tree reflections waver from side to side as they follow the movement of the water. In the lower left corner, where the water ripples are the most apparent, the sky reflections form an undulating striped pattern.

Short, horizontal lines work well to sketch rippled reflections in pen and ink.

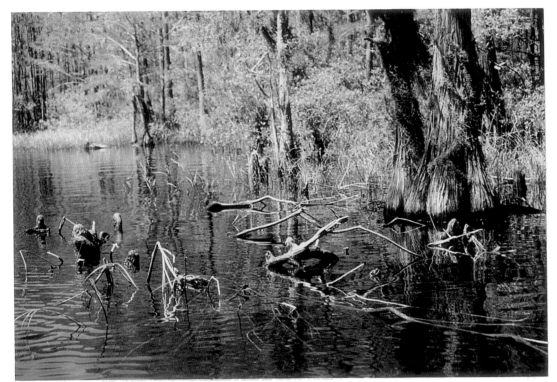

Finish by adding the deep shadows and reflective colors. I used pen and India ink for a striking contrast. ⟶

③

① ⟵ When painting ripples, lay down the palest reflective color first. This Cobalt Blue wash represents the sky reflection.

② Layer on the next darkest color.

Water Rings

Water rings are formed when moving water collides with a solid object on its surface. The resulting ripples radiate out from the object in all directions.

In this mixed media study, the log is the object which is disturbing the flow of the water.

Deep water color change.

White ripples were masked before the darker areas were painted.

Areas of solid India Ink provide a dramatic value contrast.

Note that the reflective areas of color curve around the rings.

Dark blue areas were filled in using a Pitt brush tip pen (110). I glazed over it using a light sienna colored pen (189) to tone down the intensity.

The underwater section of the log appears darker and muted in color. The shape is distorted. Ripples overlay the image.

Pale water ring reflection areas were painted in first, using washes of watercolor. This section is a mixture of Phthalocyanine Green (blue-green) and red-orange.

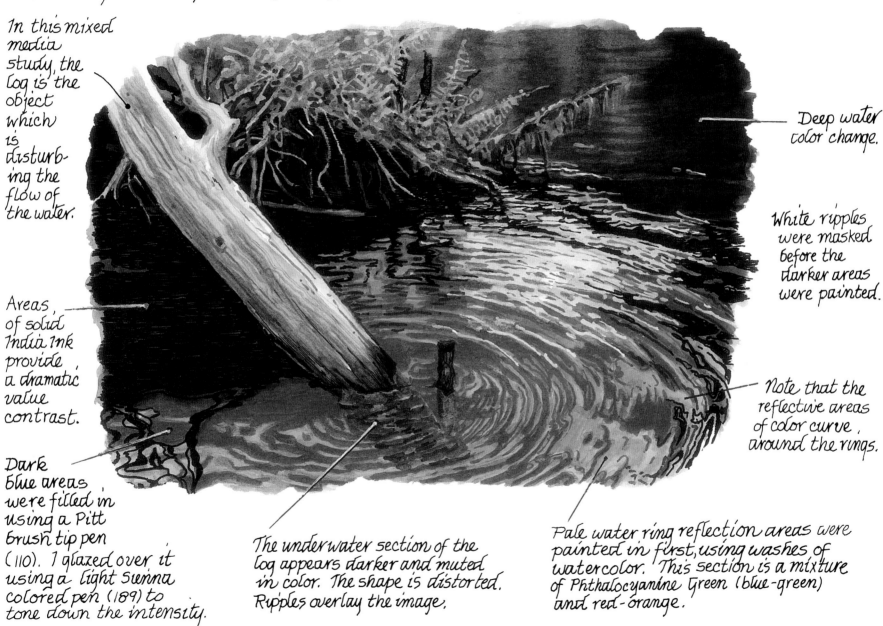

Painting Sun Sparkle

The watercolor painting on the opposite page, entitled LIGHT PLAY, is a study of how sunlight radiates through tree foliage, and dances across the riffles on the river's surface. Masking, glazing, stippled pen work and scraping were all used to achieve the effect. Study the forest background in the painting. It began with patches of varied watercolor washes. The dotted white areas were masked. Pen and ink stipple work, using PITT brush tipped pens, added the texture and radiance.

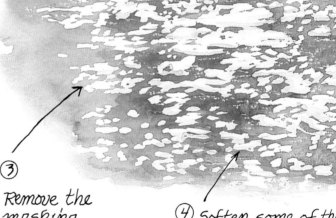

① These step by step instructions will show you how to put sparkle on the surface of rippling water.
1. Mask out the sun glare areas. They should be laying in horizontal groups as if they were melting across the surface.

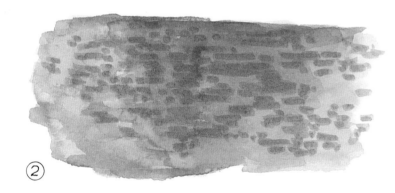

②

Sap Green plus Burnt Sienna

Dioxazine Purple and Sap Green

Sap Green and Sepia

Lay down the local color of the river, considering the color of rocks below and reflections. I used the three mixtures shown above, applying them randomly and darkening them with additional glazes of color.

③ Remove the masking. The white glare spots will appear a bit hard-edged and abrupt.

④ Soften some of the white edges by outlining them with very pale washes of the lavender mix. This is a reflection of the river water nearby. Use the corner of a razor blade to flick in additional glimmer lines and flecks.

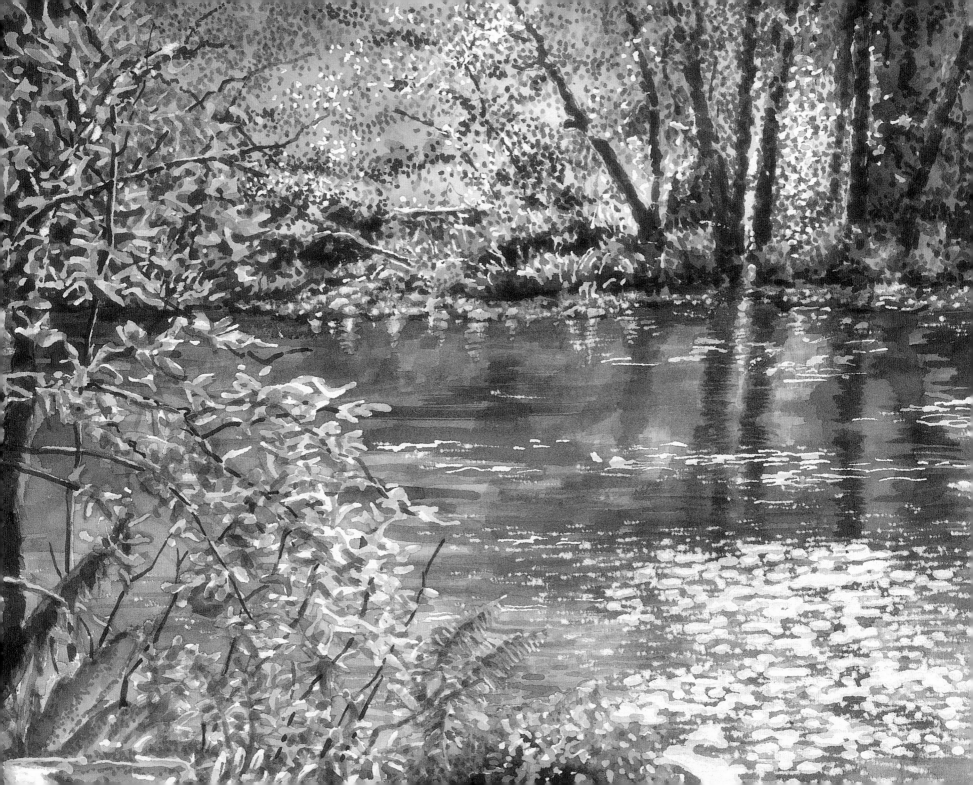

Whitewater

Falling, churning water becomes super-charged with air. The frothy, bubble-laden water reflects the sunlight like a myriad of diamonds, and we see white. The most important thing to remember when creating a whitewater scene is to preserve the white.

In a pen and ink drawing, make just enough contour or scribble lines to suggest the direction of water flow and underlying rocks. Too many lines and the water will look muddy.

When working in acrylic, paint the rocks and the local color of the water in first.

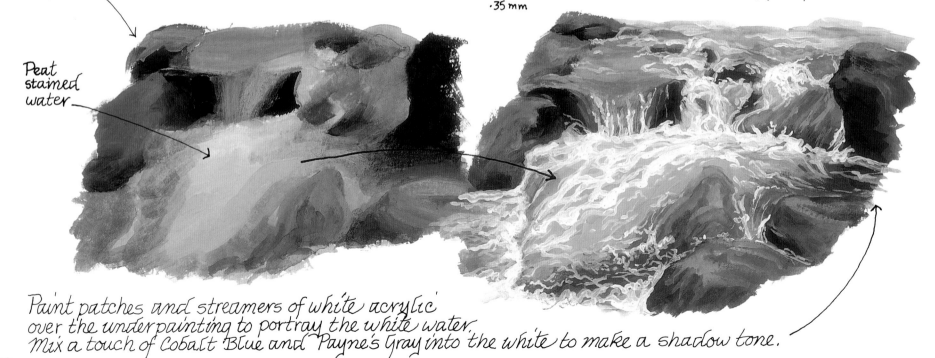

Contour or cross-hatch lines make good rocks

Contour lines will portray moving or falling water.

Use scribble lines to suggest foam.

Nib sizes .25 mm and .35 mm

Peat stained water

Paint patches and streamers of white acrylic over the underpainting to portray the white water. Mix a touch of Cobalt Blue and Payne's Gray into the white to make a shadow tone.

Watercolor Rapids ~ step-by-step

1. Begin with a pencil drawing. Think of the rise in the river as a set of uneven stairs. Remember that water may be flowing and merging from several directions. Mask out narrow white water highlights. Large white areas can be painted around.

2. Paint the colored areas of water using glazes. These will include foam shadows, pools and swiftly moving, flat surface areas. Begin with the palest hues and work towards the darkest tones.

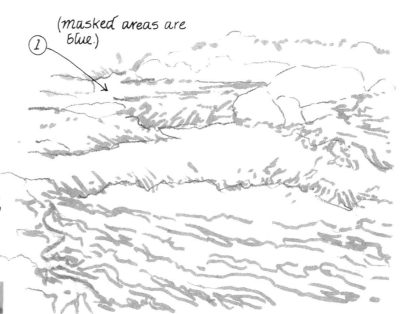

(masked areas are blue.)

①

②

The blue-green colors used to paint the water are mixtures of Sap Green and Phthalo Blue, muted with red-orange.

③

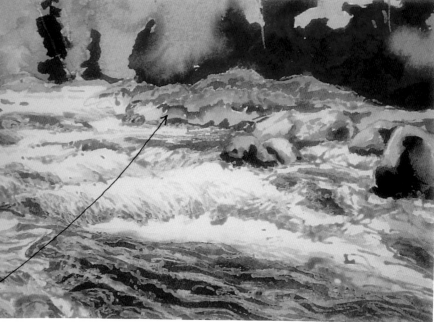

3. Block in the lightest hues in the rocks and background. Note that masking fluid was used to protect the distant tree trunk shapes and highlighted areas on the moss and rocks.

4. Protect the highlighted leaf areas in the background forest with masking fluid. Mask a few branches in the shaded areas also. The masked shapes should be tiny, delicate groupings of dots.

You may wish to mask some of the lighter hues in the rocks before moving on.

5. Glaze the next darkest shade of green into the forest area. Let it dry. Add a few more masked dots to preserve some of the newly painted color. Deepen the shadows with another, darker toned glaze.

6. Remove all of the masking fluid.

④

To see the final touches added to the painting, study the finished piece shown on the opposite page entitled SALMON RIVER RAPIDS.

Note that I tinted some of the undulating white lines in the foreground of the river with a pale wash of blue-green to soften them. The tree trunks were tinted brown and the rocks were refined with additional glazes of color and shadow tones.

The final step was a bit of Black India Ink pen work to add deep shadows in the forest and texture to the rocks in the lower, left-hand corner.

⑤

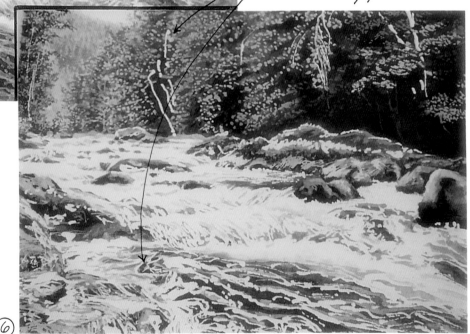

⑥

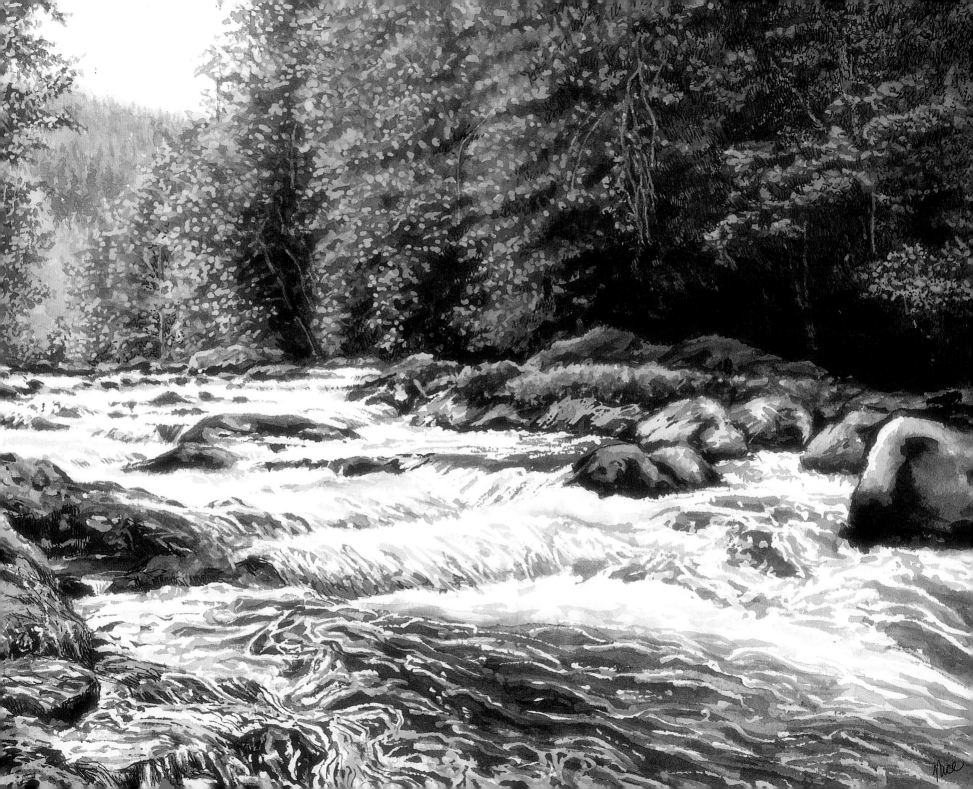

Waterfalls

A waterfall is simply an area of white water that drops an extra distance. The techniques for drawing and painting them are the same. Preserve the white! Study the pencil drawing below. Note that the dark area behind the falls was penciled in, but the white, glistening water was left paper white. The distinction between rocks and water is subtle, being created with value contrast instead of outlines.

If you're portraying a single falls, it is best to keep it offset from the exact middle of the scene. Allow it to gather in a pool rather than flowing off the bottom of the paper or canvas. It will pull the viewer's eye along with the flow.

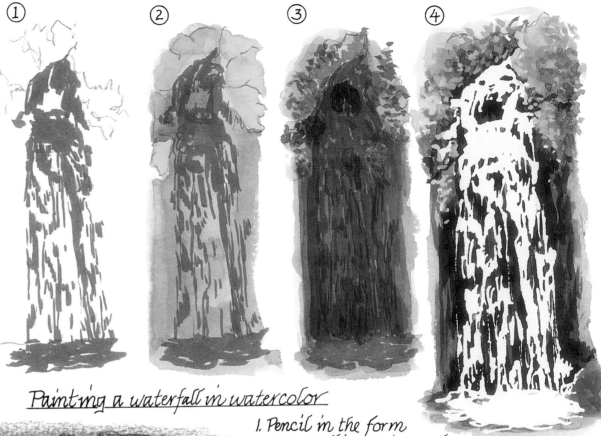

Painting a waterfall in watercolor

1. Pencil in the form of the falling water and mask it out (shown in blue).

2. Block in the basic background colors. The rocks are a mixture of Payne's Gray and Dioxazine Purple. Mixtures of Lemon Yellow, Sap Green and Permanent Green were used for the foliage.

3. Glaze in additional color to add depth. Use dots of masking fluid to protect the palest leaves.

4. Remove the masking.

5. (Opposite page) Blend a pale mix of Ultramarine Blue and Purple into the shaded areas of the waterfall.

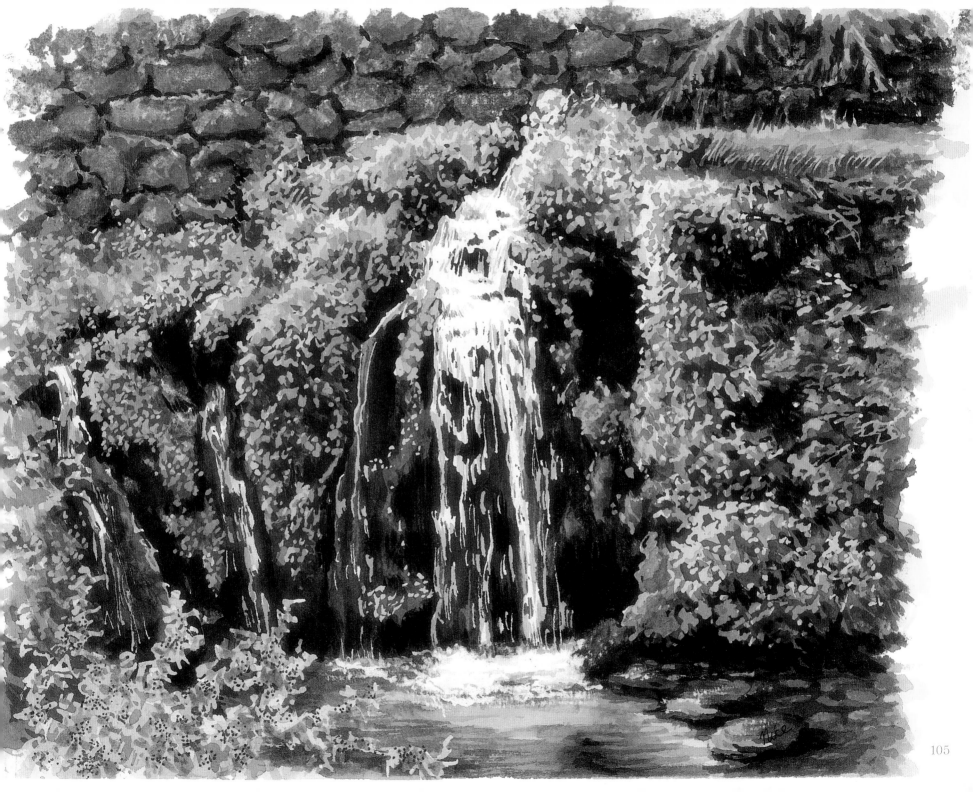

7 *Flowers* of the FIELD

I've been fortunate enough to have traveled to many countries, regions and terrains. No matter how extreme the conditions, in the right season, I have found flowers. Like familiar faces, they wait to greet me. Some are shy, tucked close to the ground and hidden behind screens of greenery. These gentle flowers are worth seeking out. Others are flamboyant peacock flowers that beg to be noticed and admired. They often stand alone against a backdrop of neutral hues, like prima ballerinas. When captured in an artistic rendering, they usually wind up as the center of focus.

In my wanderings, I find that country roads and paths most often lead me to vistas of open fields. It's there that I find the wildflowers gathered in legion. They frolic in and above the grasses, with faces of many shapes and colors, intermingled in a joyous worship of the sun. This chapter is dedicated to these landscape flowers, which are content to be a part of the scene, instead of dominating it.

While bright foreground blossoms can help focus a viewer's eye in a certain locale, those same flowers, their colors muted with distance, can lead one into the depth of the landscape. Such is the field of red poppies on the facing page. This painting was inspired by my travels in Scotland. Note how the perky red blooms help to orchestrate the scene rather that dominate it. As artists, it's our mission to step beyond what the camera can capture, and to arrange the shapes, colors, values and textures into combinations that transform a pretty scene into a masterful landscape. Florals can be a powerful tool in this process.

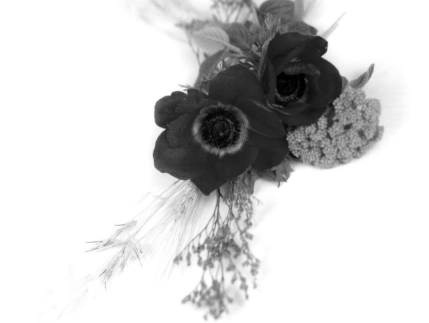

POPPIES IN WILD ARRAY
Watercolor, painted from a photo taken in Scotland.

Wild Grass

It's not hard to draw a blade of grass. The stroke is long and gently curved. A group of grass blades is a collection of criss-cross lines which tend to lean in one direction if the wind is blowing.

Dots work well to suggest seed heads.

Varied lengths and shades of color.

Short grass is drawn in a similar manner.

Grass plants are drawn in individual clumps only when depicting areas of sparse vegetation.

For dry grass washes, try mixtures of these colors—

Burnt Umber, Burnt Sienna, Sepia, Yellow Ochre, Cadmium Yellow, Cadmium Orange and Dioxazine Purple!

To portray a foreground field of wild grass, follow these steps. —

1. Mask out a fair number of tall criss-cross lines with masking fluid. Let dry.

2. Dampen the paper and stroke a vertical, varied wash over the entire fore-ground area.

3. When the wash is dry, remove the masking fluid.

4. Use pale hues to tint the grass blades. Leave some of the tops white to show sun reflection.

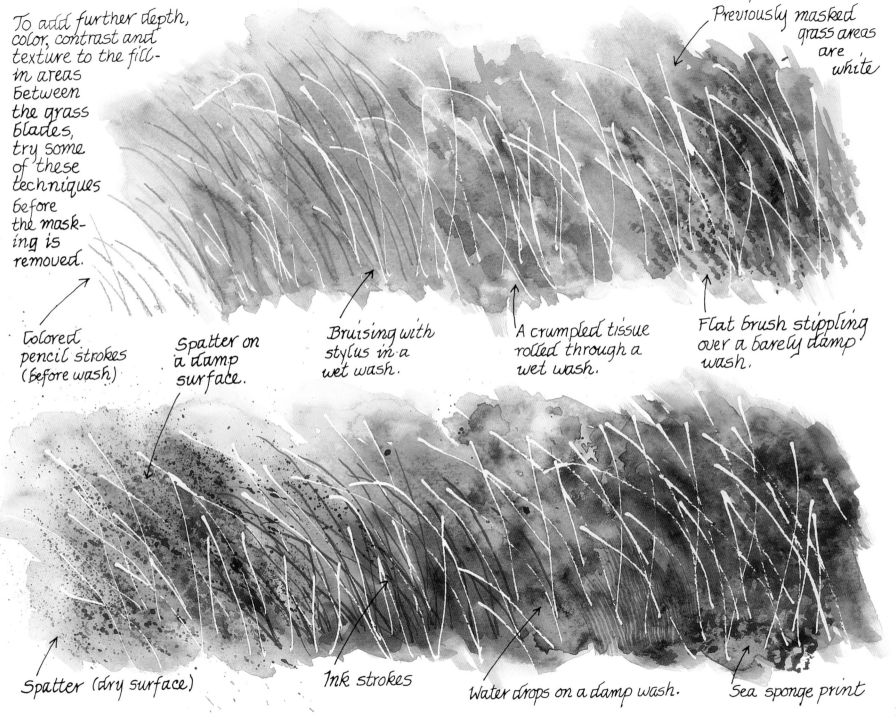

To add further depth, color, contrast and texture to the fill-in areas between the grass blades, try some of these techniques before the masking is removed.

Previously masked grass areas are white

Colored pencil strokes (before wash)

Spatter on a damp surface.

Bruising with stylus in a wet wash.

A crumpled tissue rolled through a wet wash.

Flat brush stippling over a barely damp wash.

Spatter (dry surface)

Ink strokes

Water drops on a damp wash.

Sea sponge print

Distant Fields

Distant grass fields are suggested more by color than texture. As one gazes across the fields towards the horizon, only the tops of the grasses are apparent. They seem to stretch across the land forming bands of color and movement similar to waves. With distance, the color of the grass pales and becomes more muted.

Study the color chart to the right. The first column represents some of the colors that I used to paint the foreground grasses in the landscape on the opposite page. By mixing them with their complimentary colors (second column), I created muted shades that worked well for the middle-ground and background of the field. Note that the shade gets more gray as more of the compliment is added (far right). These are good hues for wood and stone.

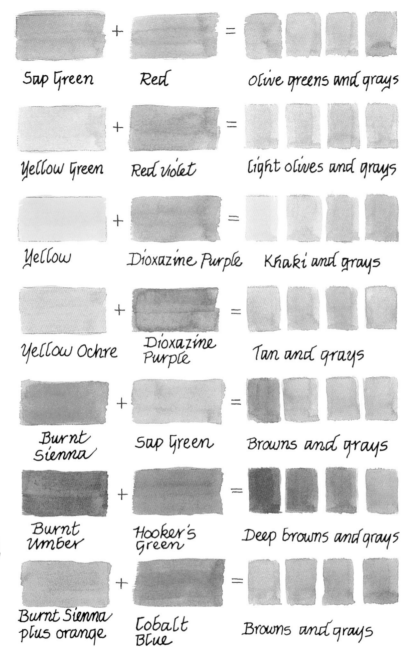

Sap Green + Red = Olive greens and grays

Yellow Green + Red Violet = Light olives and grays

Yellow + Dioxazine Purple = Khaki and grays

Yellow Ochre + Dioxazine Purple = Tan and grays

Burnt Sienna + Sap Green = Browns and grays

Burnt Umber + Hooker's Green = Deep browns and grays

Burnt Sienna plus orange + Cobalt Blue = Browns and grays

① To portray a distant field, stroke warm, muted yellows, greens and browns horizontally across the watercolor paper, using a round or small flat brush. Work on a damp or moist surface and allow the colors to blend freely.

② When the first paint layer is dry, glaze on some subtle horizontal shapes to represent shadow areas and a variety of weeds and grasses. Use a clean, damp brush to soften the edges.

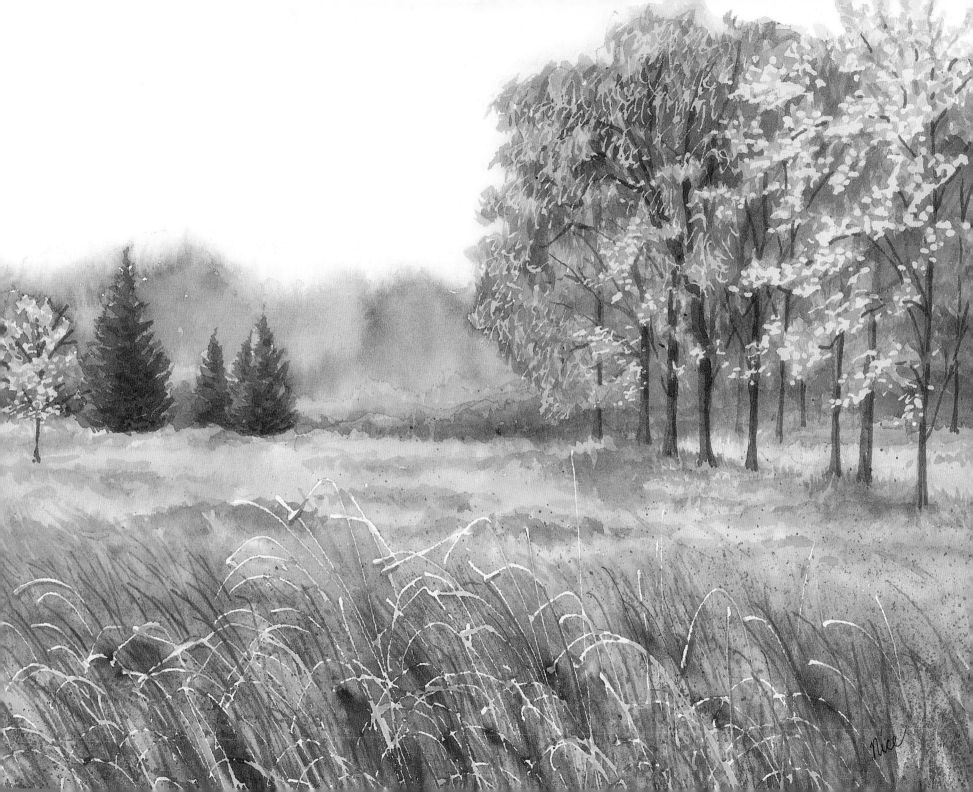

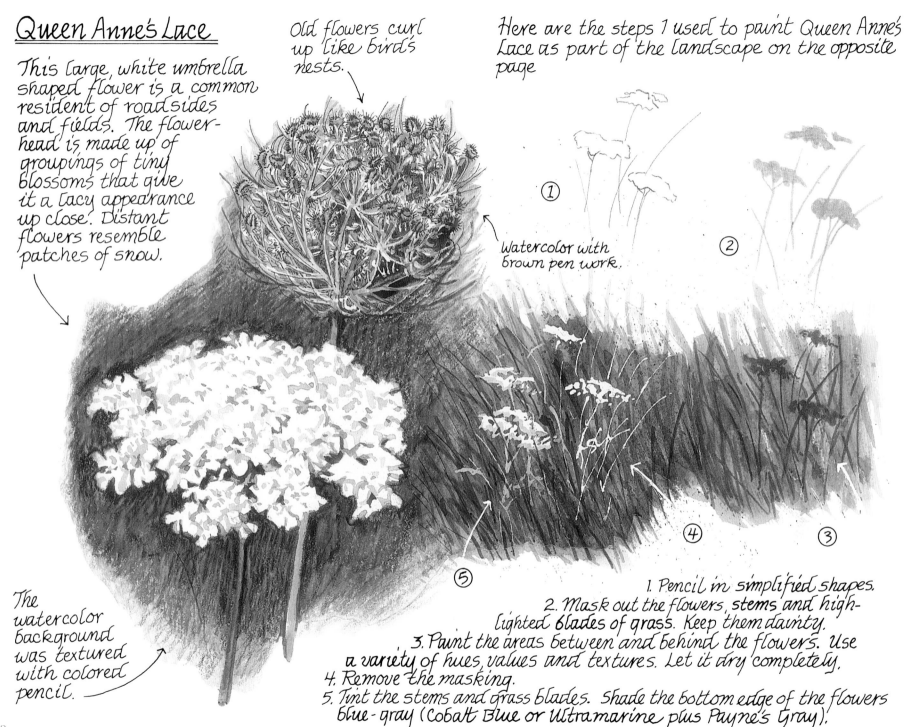

Queen Anne's Lace

This large, white umbrella shaped flower is a common resident of roadsides and fields. The flower-head is made up of groupings of tiny blossoms that give it a lacy appearance up close. Distant flowers resemble patches of snow.

Old flowers curl up like bird's nests.

Here are the steps I used to paint Queen Anne's Lace as part of the landscape on the opposite page

Watercolor with brown pen work.

The watercolor background was textured with colored pencil.

1. Pencil in simplified shapes.
2. Mask out the flowers, stems and high-lighted blades of grass. Keep them dainty.
3. Paint the areas between and behind the flowers. Use a variety of hues, values and textures. Let it dry completely.
4. Remove the masking.
5. Tint the stems and grass blades. Shade the bottom edge of the flowers blue-gray (Cobalt Blue or Ultramarine plus Payne's Gray).

A few other umbel-shaped wild-
flowers that work well in a field
painting are sketched below.

Sweet
fennel

Yarrow

Dried

Pearly
Everlasting

Sea
sponge
print

Pen &
ink

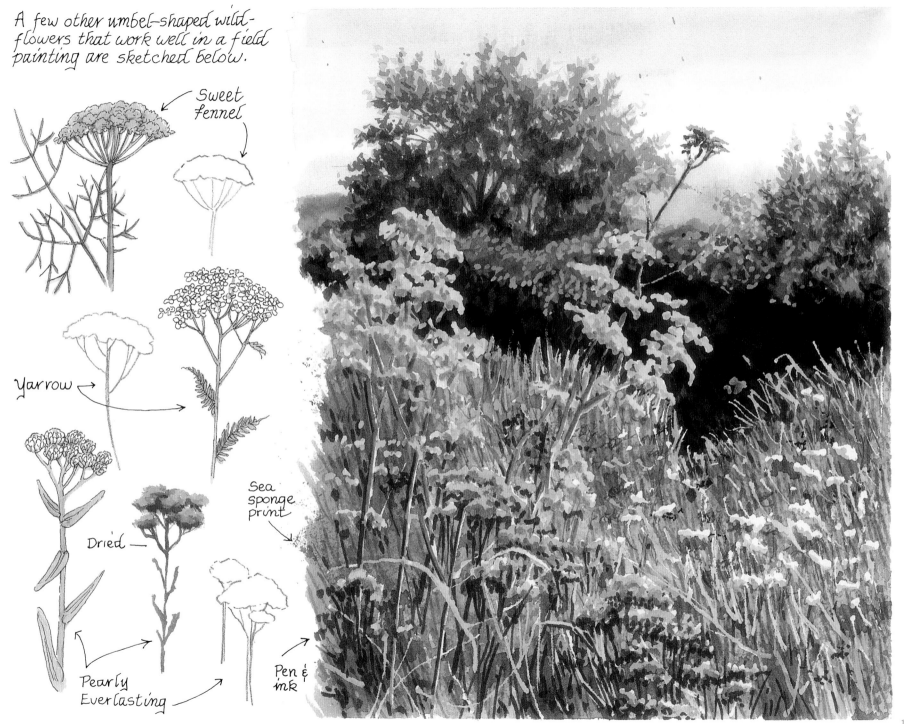

Tall Flower Stalks

These wildflowers rise above the grasses of the field and work well to add color to a pastoral landscape. Keep details to a minimum.

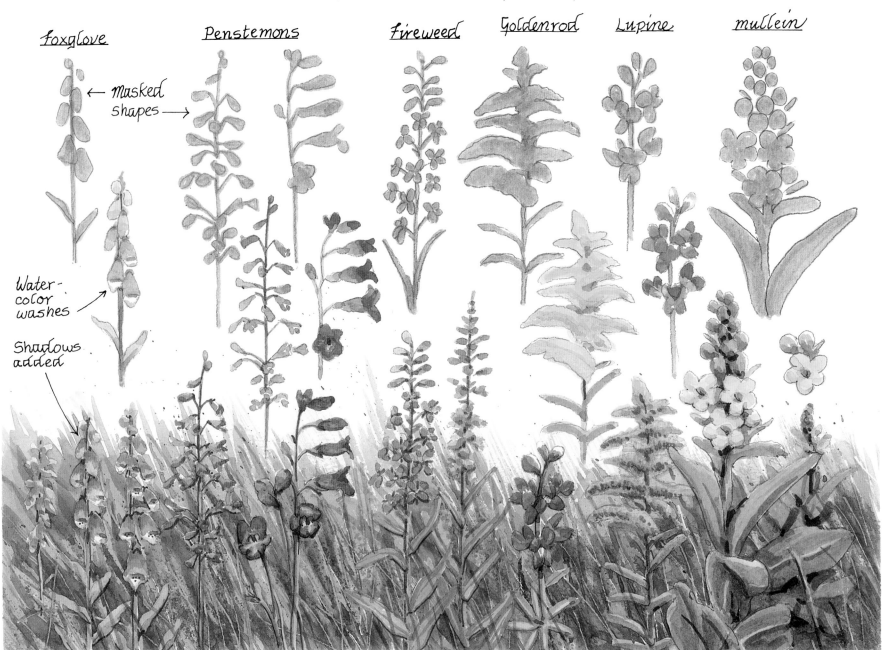

Foxglove

← Masked shapes →

Water-color washes

Shadows added

Penstemons

Fireweed

Goldenrod

Lupine

Mullein

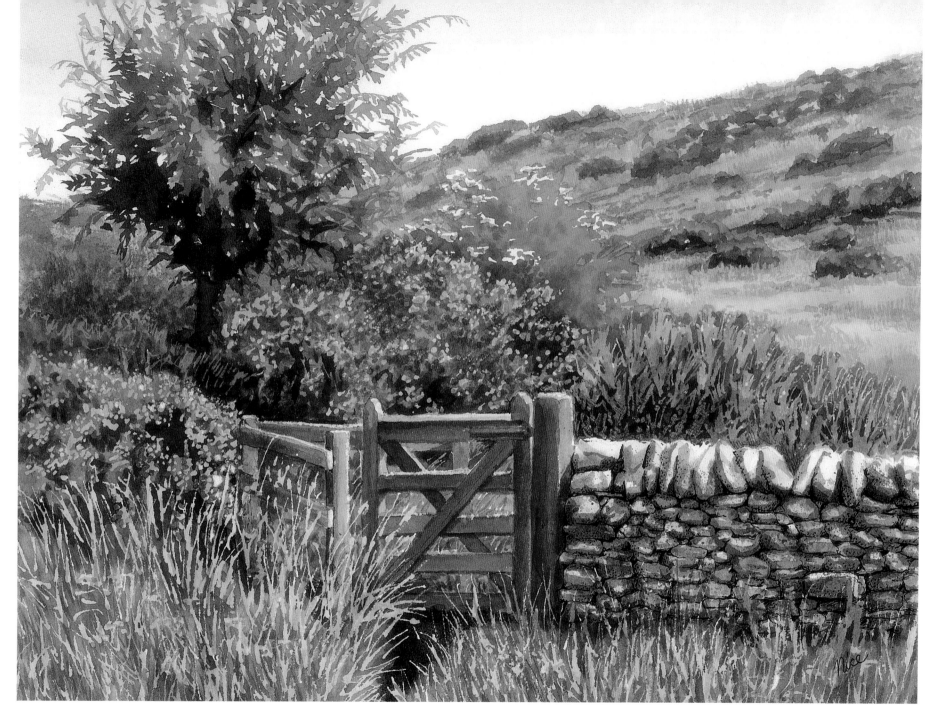

KISSING GATE
Watercolor with pen and ink detailing.

Rock Salt Ray Flowers

Bee-balm
(mint family)

Flower head

Coneflower

Bract

Aster

Chicory

Ray flowers (composites) have a rounded, compact head and radiating bracts.

Distant ray flowers can be suggested by placing a **wet** piece of rock salt in a small, ragged edged wash puddle of the appropriate color. When dry, flower centers can be scraped white and painted.

To create a grouping of ray flowers, lay down a water color wash. Let the paint settle until it's moist and shiny, not runny wet, then use a pair of tweezers to dip a piece of rock salt in water and place it into the wash. Add more pre-moistened salt pieces, spaced 3/4 of an inch (2 cm) apart. Leave the salt in place until it is dry. Paint the flower centers. Use a razor to scrape in highlights.

Rock salt design roughed in.

Flower center roughed in.

Highlights and shadows

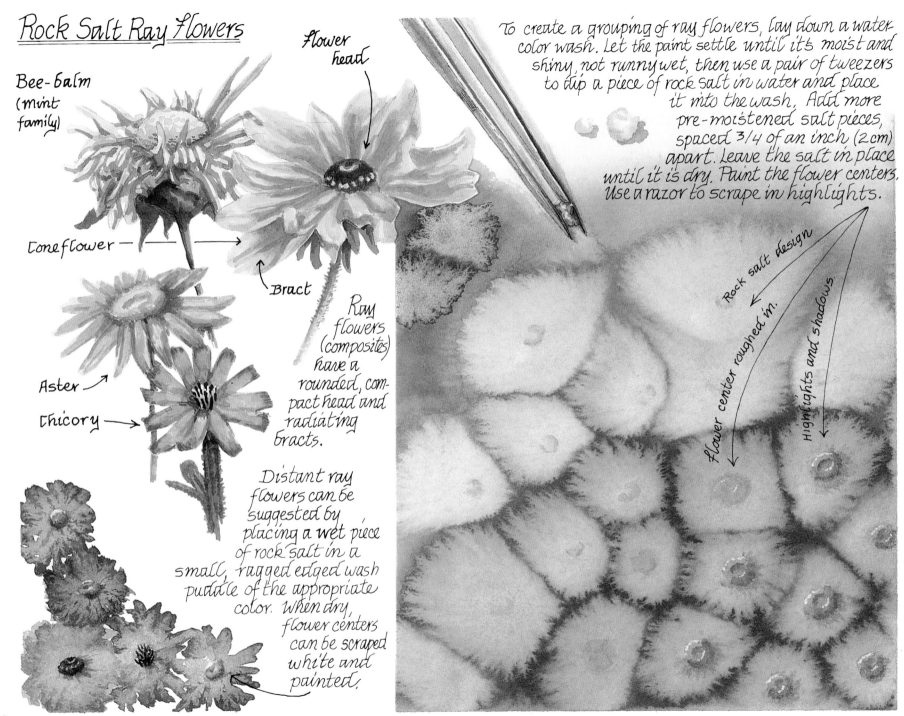

Ox-eye Daisies

These common little field flowers are useful to perk up a dark area in a landscape. Their pale hues are easily combined with brighter florals. Both rock salt and masking was used in this water-color scene.

Draw an ellipse to create a basic daisy shape.

Use a dark background to contrast the white rays.

This is the basic shape to mask out for daisies seen at a distance. Flower-heads will not appear round unless the viewer is looking directly down at them.

Base color

Shading added

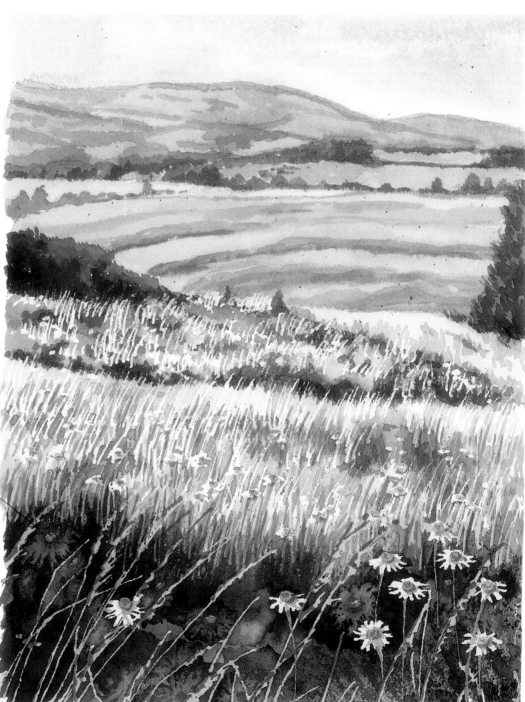

117

In-Depth Floral Studies

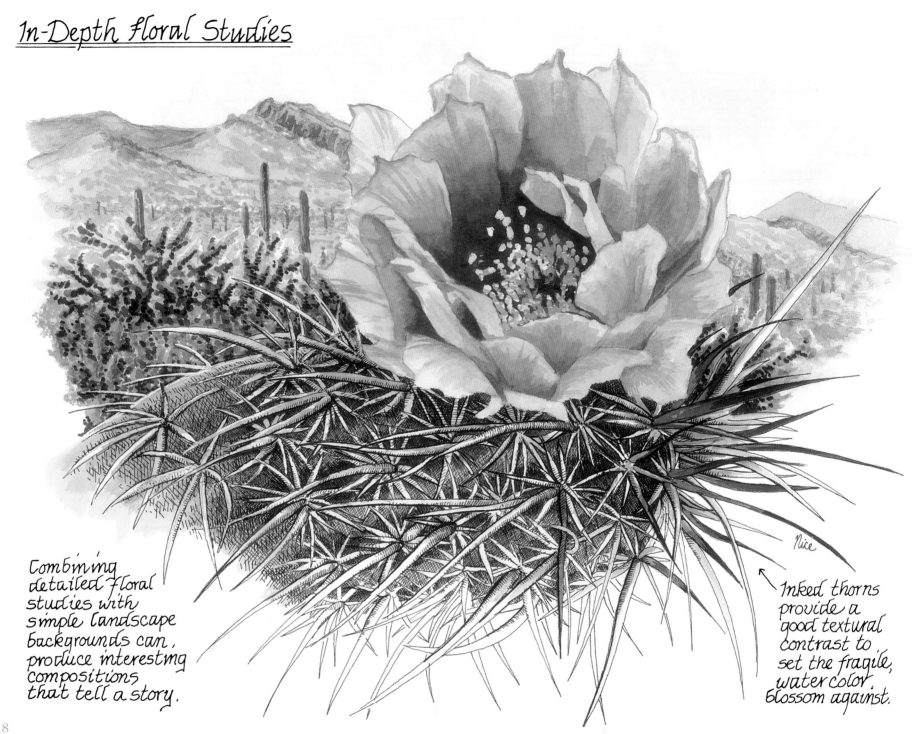

Combining detailed floral studies with simple landscape backgrounds can produce interesting compositions that tell a story.

Inked thorns provide a good textural contrast to set the fragile, watercolor blossom against.

The prickly plant (opposite) is a Hedgehog cactus. I was fascinated by its tenacity. It had been tipped over, yet managed to bloom! In the background, I painted Cholla cactus, magenta Owl clover and Lupine, in muted tones to distance them. The touch of landscape tells the environment in which this cactus grows.

Texas Bluebonnets are the main focus in the watercolor study on this page. Note how the detail and brightness decrease as flowers recede. Both background scenes were painted using glazing techniques rather than masking. This kept the edges soft and the texture subdued.

Leaving a white space between the featured plant and the background helps to emphasize the main subject.

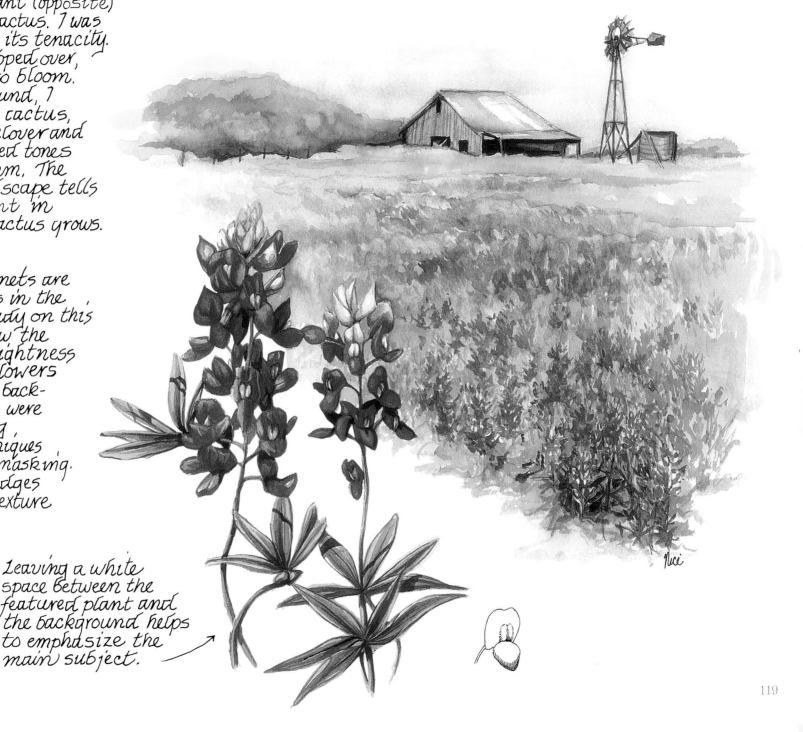

8 PLACING the *Human Touch* into your LANDSCAPES

When mankind mingles with nature, there is usually some kind of imprint left, whether it be a permanent structure or just a worn pathway. New buildings, fences or concrete highways are not necessarily friendly to the beauty of a landscape, but when man-made structures have settled into their surroundings enough to take on the patina of time, they can add a touch of nostalgia to the scene.

Consider the watercolor painting on the facing page. The scene actually exists, looking much the way I depicted it. I was walking in spring green pastures, far from home, when I came across this ancient stone wall with its weathered gate and sturdy old stile. As you can see, the stile is a convenient stairway up and over the wall, which people can easily climb, but livestock cannot. As I studied the worn rungs of the stile, I realized that it revealed an intriguing tale about the past and the people who worked in these fields. Pondering who had gone before me, I could not resist climbing up and over the stalwart old relic. Before I left, I documented the scene, with several snapshots and a quick sketch in my journal. When it came time to organize my memories into a painting, I used contrast to add vitality to the landscape; wooden structures, gray with age, are set against the vitality of green growing fields. One intensifies the look of the other. The wood looks older, the grass looks brighter.

In this final chapter, I will show you how to draw and paint believable buildings, bridges, fences, roads, and pathways, and how to fit them subtly into the landscape. If they can tell a story or add a bit of sentiment to the scene, it will make the painting that much more interesting.

STILE IN THE SPRING MEADOW
Watercolor with pen and ink.

Perspective Made Simple

Perspective is the illusion of form and depth that an artist (or camera) creates when depicting three-dimensional objects on a flat surface. In order to make the illusion seem real, a prescribed set of principles must be followed.

① The horizon line and the eye level at which the artist is viewing the scene is the same. He will look up and under objects that are above his eye level (A), and down upon those objects below his eye level (C). Subjects that are even with the artist's eye level are viewed straight on (B). Keep in mind when combining objects from different scenes that there is only one "point of view" per composition. For example, one can't take an eye level building from one scene and place it above or below the eye level in a different landscape. It would look out of place.

② Objects appear to grow smaller, more narrow and less bright as they recede into the distance towards the horizon line (C-E).

Vanishing Point

Horizon line or eye level

③ Lines that run parallel to the ground and each other, like a building's roof ridge and foundation, the upper and lower edges of a window or the two sides of a road (F), will appear to move closer together as they recede into the distance. If the lines were extended as shown by the dotted lines in the illustration, they should converge and disappear at a single vanishing point located on the horizon line. Each side of a building will have its own vanishing point. Different objects in a scene may have different vanishing points, but they will all be located somewhere along the horizon line.

④ sets of lines that run parallel to each other but not to the horizontal ground plane, will also appear to move closer together as they stretch away from the viewer. Study the diagonal gable roof lines (G). Note that the pitch of the back gable roof line is less steep than the front gable. If these diagonal lines were fully extended, they would meet at an oblique vanishing point above the page, over the vanishing point for the right side of the building. Unless they are extremely tall, draw the vertical edges of buildings straight up and down.

Drawing In Perspective

Although an artist may lay out a drawing using vanishing points and a ruler, most of us enjoy the challenge of drawing a subject freehand, while keeping the principles of perspective in mind. Then if the resulting sketch seems out of whack the ground rules of perspective can be used to find and correct errors. Consider this pencil sketch of a house.

① Any two lines parallel to the horizontal ground plane can be extended to locate the house's vanishing point.

Horizon line

1. Something in the roof area seems out of perspective. To check it, I need to determine the location of the horizon line, and the vanishing point which corresponds to the right side of the building. To find the vanishing point I simply extend the foundation line and the eave line until they cross. The horizon line runs through that point.

②

Horizon line

oops!

2. Having determined the vanishing point, I can check the rest of the building. The windows line up with the vanishing point correctly, but the roof top does not. The corrections, shown in blue, will bring it into perspective. Although the lines for the left side of the house do not converge on this page, they will come together at a single point which rests upon the same horizon. I checked to be sure!

It's helpful to know that two diagonal lines, drawn corner to corner can be used to determine the center of the side of a building drawn in perspective. Study figure (c) on the oppsite page. A vertical line drawn upward through the "X" will provide an accurate ridge for the roof. The pitch of roof depends on how far the ridge line is extended.

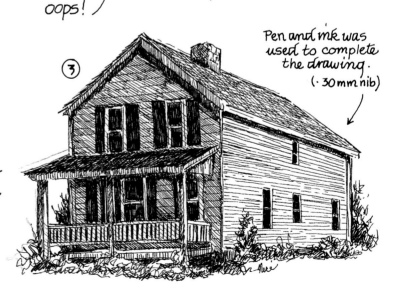

③ Pen and ink was used to complete the drawing.
(.30mm nib)

Background Buildings

Adding a building into a landscape will provide an area of focus. The closer to the front it is placed, the more attention the building will demand. Shown here is a sampling of small structures that would fit nicely into a landscape background. Detail is minimal and they require only a touch of texture. I have included a brown horizon line in each drawing so they can be placed easily into a scene, should you decide to borrow one.

Tiny daubs or lines from the tip of a round detail brush (no. 4 or smaller) can suggest roof shingles or rows of bricks.

Watercolor

A combination of watercolor washes and Pitt (brush nib) pens were used to paint this little Victorian house.

When the artist views a house straight on and centered, the side walls are not seen. This type of view is called one point perspective.

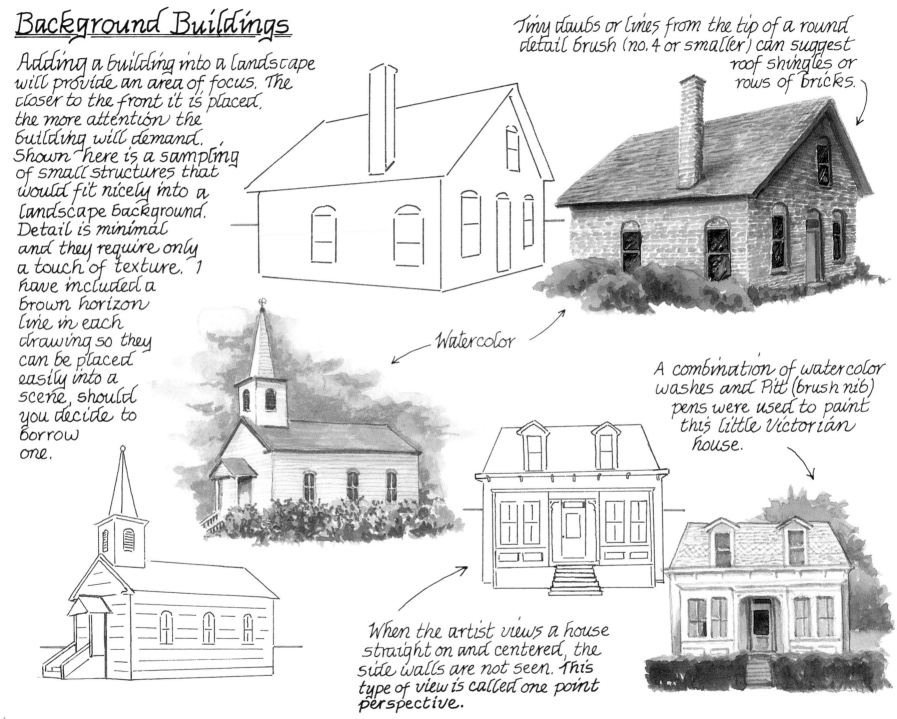

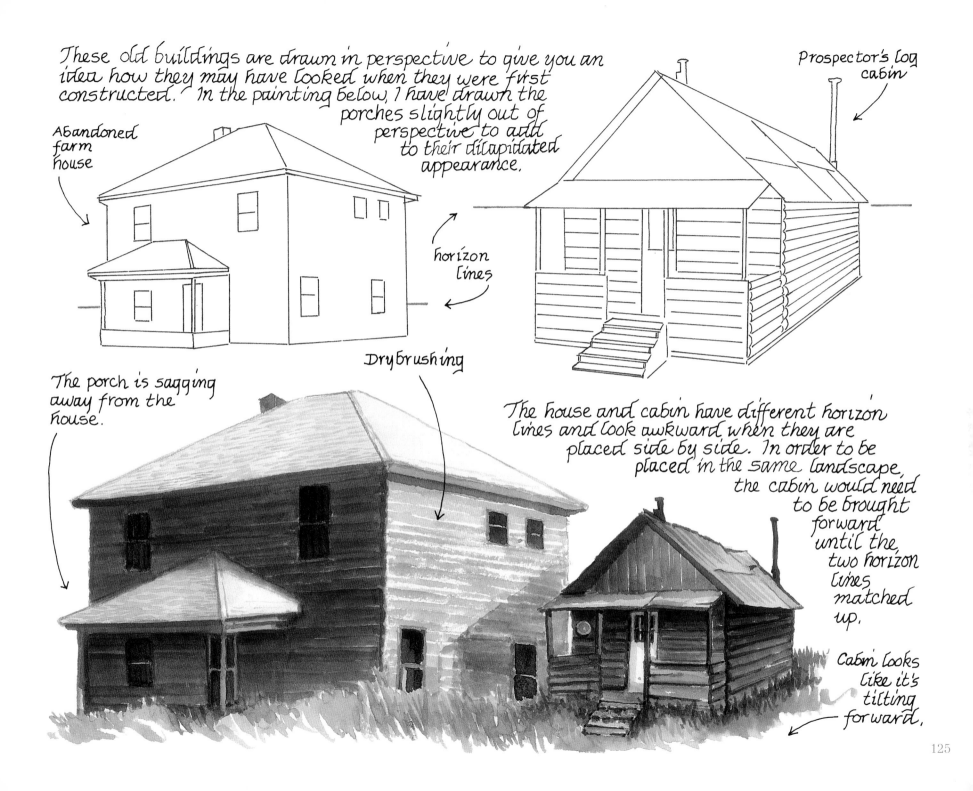

These old buildings are drawn in perspective to give you an idea how they may have looked when they were first constructed. In the painting below, I have drawn the porches slightly out of perspective to add to their dilapidated appearance.

Abandoned farm house

Prospector's log cabin

horizon lines

Drybrushing

The porch is sagging away from the house.

The house and cabin have different horizon lines and look awkward when they are placed side by side. In order to be placed in the same landscape, the cabin would need to be brought forward until the two horizon lines matched up.

Cabin looks like it's tilting forward.

125

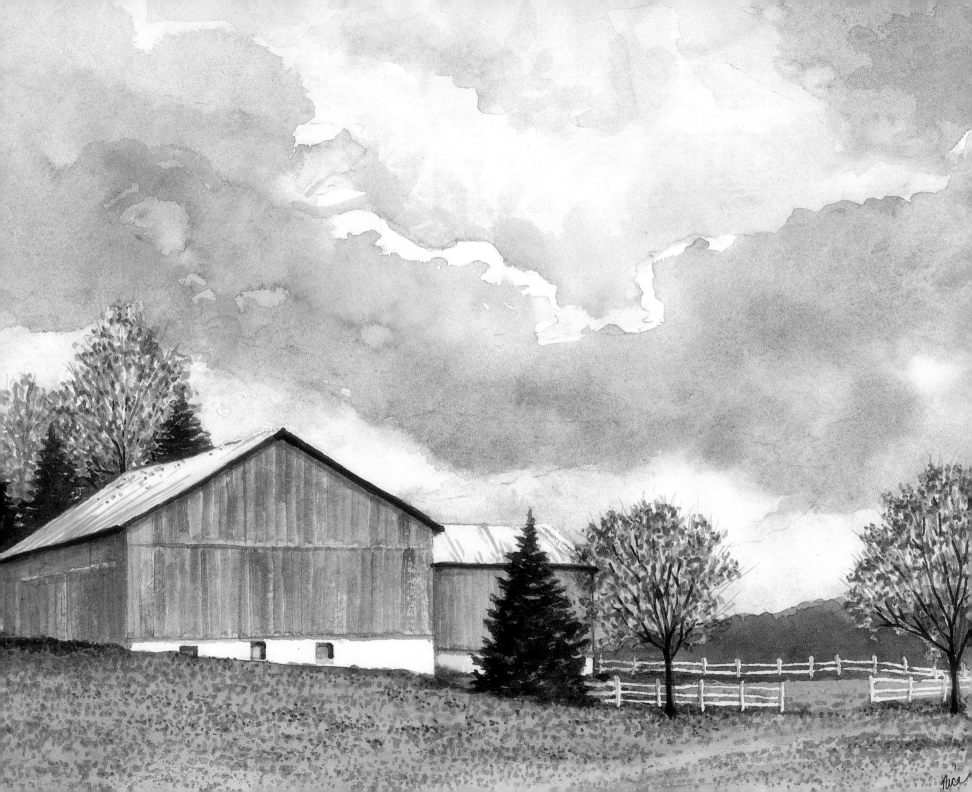

Distant Weathered Wood

The cracks, splits and general roughness that wood takes on as it ages in the elements cannot be seen at a distance, at least not in detail. However, it can be suggested by muting the colors and using a drybrush technique to stroke in the boards.

① Begin with a drawing. This barn is set on a hill. The horizon line is below it.

No. 4 round brush.

A drybrush stroke shows the texture of the paper.

② Apply the palest color in each area as a base. Use mixtures of complimentary colors to create muted (not muddy) grays and browns. I used watercolor paints for this little painting.

This gray is a mix of Cobalt Blue and orange. Several variants of the same mix were used in step three.

Colored ink stippling

③ Add shadows and details. I suggested the weathered wooden siding with long vertical strokes with a round brush. The brush was dipped in one of several gray mixtures, blotted several times, then applied. The blotted brush skimmed over the texture of the paper, creating a roughened appearance.

A Rapidograph pen was used to sketch this ink drawing.

(.25 mm nib)

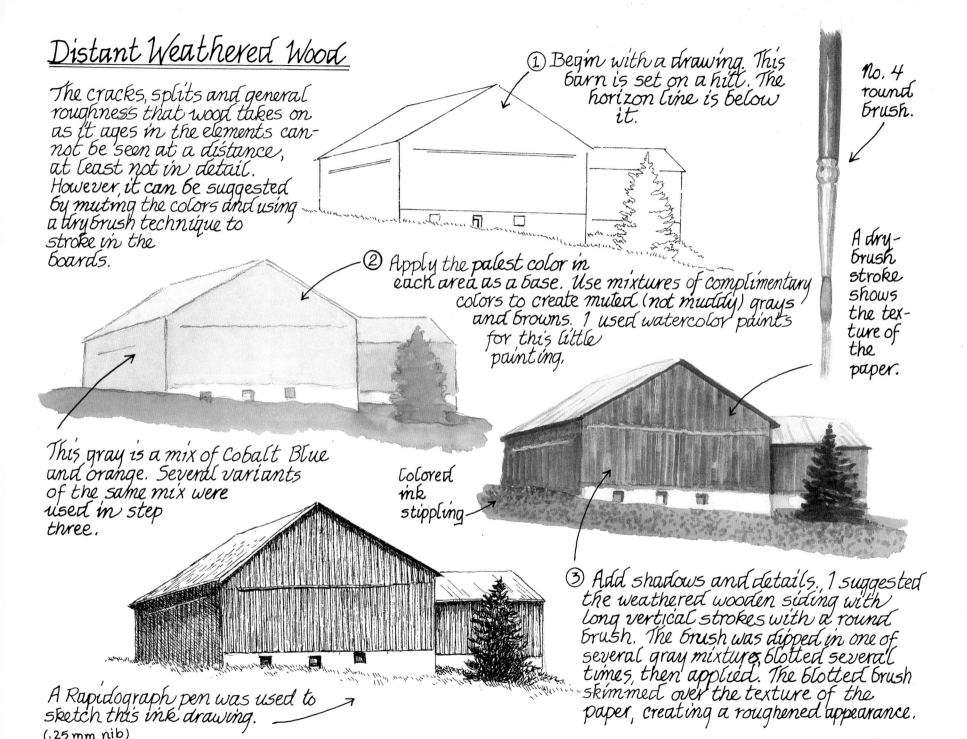

127

Acrylic Buildings

The opaque nature of acrylic paint lends itself well to the depiction of solid, non-translucent structures like buildings. It provides the artist with the advantage of being able to paint fine, light colored detail lines over dark backgrounds.

Study the acrylic painting on the opposite page - WHITE BARN LANDSCAPE - 9 x 12 inches (22½ x 30 cm.) The light over dark layering technique was used to detail and texture the barn, and also to develop the water and foliage areas. Here's how it was done.

① The building and the rest of the scene was sketched on canvas using pencil. It's shown here in pen and ink for better viewing.

Viridian Green/Sap Green mix stroked over Payne's Gray

Burnt Umber
Burnt Umber/White

② The base colors were blocked in using a small flat brush and a no. 4 round brush. Both were synthetic fibers.

The gable in the dormer is a Payne's Gray/White mix.

③ The white walls of the barn were partially glazed with thinned down versions of the colors used to paint the dormer in the roof. White was added to the base colors and a no. 0 round detail brush was used to highlight and texture the roof, windows and foliage. The grass was warmed with a touch of yellow/white.

128

Bridges

The tree prevents the strong horizontal lines of the bridge from pulling the eye out of the composition.

When drawing bridges, think of them as partial buildings, suspended in the air. They have horizon lines and vanishing points that they must relate to. It is also a good idea to show one or more areas of support, so the bridge does not appear to be floating.

Thumbnail sketches and mini paintings like the ones shown on this page, help an artist visualize a larger painting in terms of its composition.

Points of Support

This one-point perspective bridge is centered in the middle of the composition. Such a design is too static to hold the attention of the viewer for long. Adding more landscape to one side would help offset the bridge.

This bridge is also centered. Even worse, the structure flows out of the painting on both sides. It needs to be set further back into the landscape and shifted a little to one side or the other. Overlapping foliage will also help subdue the strong horizontal lines.

Distant Stone Masonry

When stonework is too far away to see details, I use a no. 2 round detail brush and daub a stone-like texture over a pale base wash. Color is important. For the stones in this scene I used mixtures of Permanent Green Lt. and Quinacridone Rose watercolor.

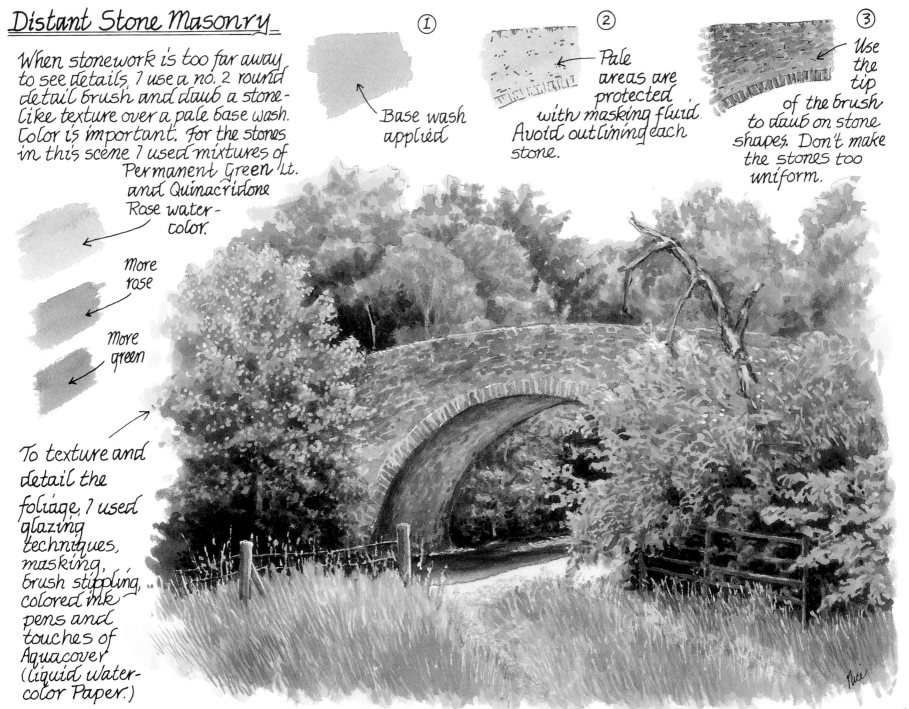

① Base wash applied

② Pale areas are protected with masking fluid. Avoid outlining each stone.

③ Use the tip of the brush to daub on stone shapes. Don't make the stones too uniform.

More rose

More green

To texture and detail the foliage, I used glazing techniques, masking, brush stippling, colored ink pens and touches of Aquacover (liquid watercolor paper.)

Obscure Lines

While foliage can lend grace and beauty to a landscape, it can also hide important structural lines. Such is the case in the photo of the foot bridge on the right. I decided to sketch the entire bridge to get a better idea of its overall shape. Drawing the railing on the right side was a bit of a guess. Having knowledge of how perspective works, helped a lot.

When I was happy with my sketch, and it took three tries, I ran extended lines from the parallel parts of the railing to see how well they came together at the vanishing point. The lines do not come together perfectly, but the perspective is close enough to be believable.

The posts have been straightened.

Note how the perspective of the camera caused the posts on the left to lean diagonally. Straightening them to a vertical position will be more pleasing to the viewer.

The bridge is slightly arched and the view we are seeing is foreshortened. Both of these aspects make it more difficult to draw than a straight bridge seen in a one-perspective view. However, it makes a much more interesting subject.

Opposite page:
LUPINE CROSSING

The painting is watercolor with pen and ink detailing. (colored PITT brush nibbed pens).

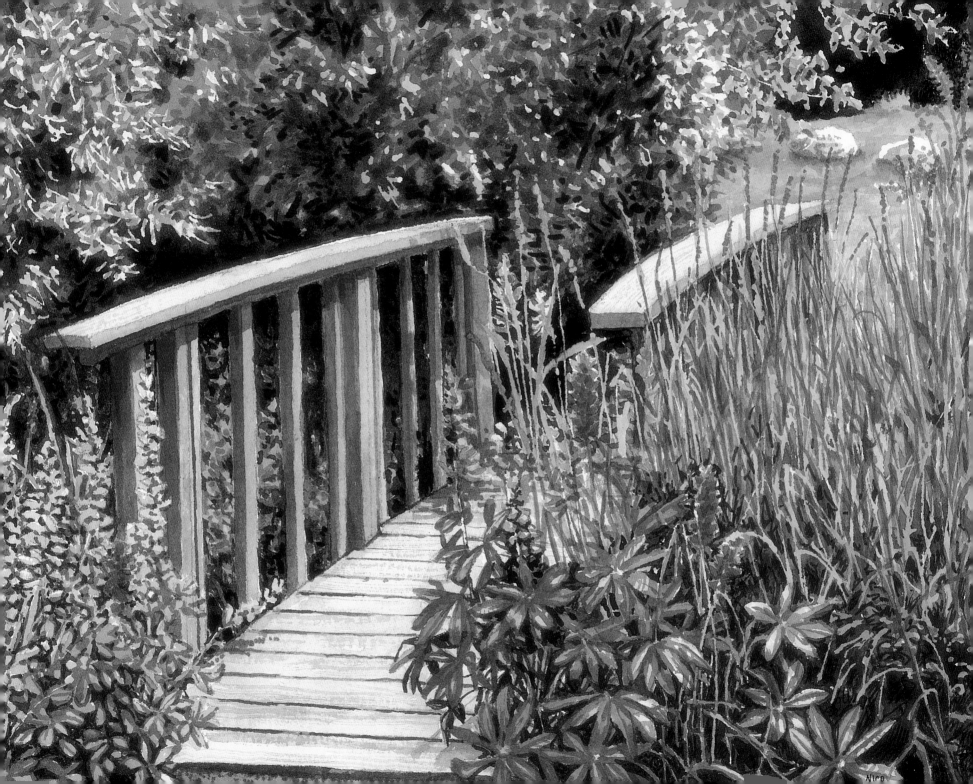

Fences

If you're drawing a straight fence on level ground, here is an easy way to keep the fence posts evenly spaced and in perspective as they recede into the distance.

Horizon line

1. Pencil in the nearest foreground fence post (A).

2. Determine where the horizon (eye level) will be in your drawing, and at what point along the horizon line you wish your receding fence to disappear (red dot).

When fence sections curve around a corner, some of them will appear foreshortened, in which case the "spacing formula" will not work. Each section of the curved part of the fence will relate to a different vanishing point as shown by the sets of dark and light blue lines shown above.

3. Draw an erasable line from the top of post (A) to the vanishing point. Draw a second line from the middle of post (A) to the same vanishing point. A third line will be drawn from the bottom of the post to the vanishing point. These lines, shown as blue dashes in the example, will act as guide lines to indicate the top, middle and bottom of each post as they grow smaller.

4. Decide how far apart you want the fence posts to be and draw in post (B). It should touch both the top and bottom guide line, with the middle line dividing it in half. It will be narrower than post (A).

5. Determine the spacing for post (C) by running a diagonal line from the top of post (A) through the middle of post (B) and downward (shown as a red broken line). Where the red line crosses the bottom blue line, is the placement for post (C). The top of post (B) will be used to figure the placement for post (D). Note: The posts get placed closer together as they recede.

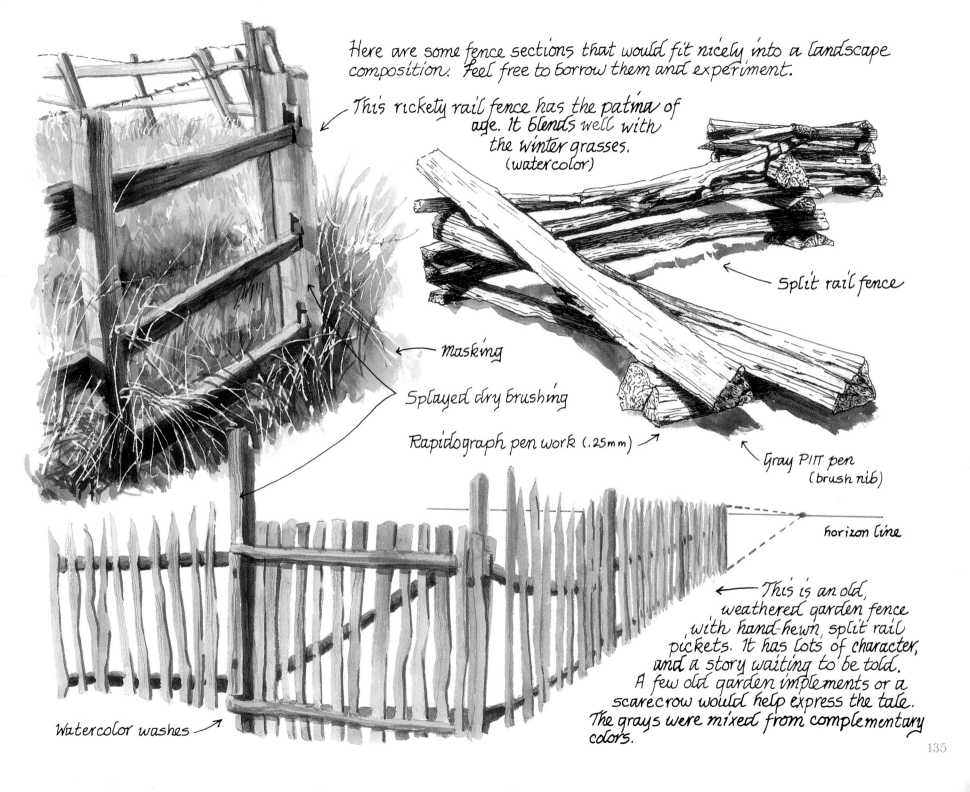

Here are some fence sections that would fit nicely into a landscape composition. Feel free to borrow them and experiment.

This rickety rail fence has the patina of age. It blends well with the winter grasses. (watercolor)

Split rail fence

Masking

Splayed dry brushing

Rapidograph pen work (.25mm)

Gray PITT pen (brush nib)

horizon line

This is an old, weathered garden fence with hand-hewn, split rail pickets. It has lots of character, and a story waiting to be told. A few old garden implements or a scarecrow would help express the tale. The grays were mixed from complementary colors.

Watercolor washes

135

Painting a Metal Patina

As metal ages, especially bronze, it oxidizes and becomes coated with a greenish film. This patina adds wonderful character to the metal. Here, shown step by step, is an easy way to paint a patina.

① Base coat the various metal parts with light yellow-green watercolor.

Mixtures of Permanent Green, Sap Green and Hooker's Green.

② Glaze the metal sections with a thin wash of Burnt Sienna. Let it dry. Add more washes of Burnt Sienna to the shadows.

Blend the edges with a clean, damp brush.

The areas between the leaves were filled in with dark green ink in a Rapidograph pen.

③ A final glaze of Burnt Umber / Dioxazine Purple was blended into the deepest shadow areas of the metal. The leaves were also shaded with watercolor.

Opposite Page: THE BACK GATE, 8 x 10 inches (20½ x 25½cm). The landscape was painted in watercolor with pen and ink detailing. The dark green ink used in the foreground foliage is a mixture of Green ink, Brown ink, and a few drops of Black.

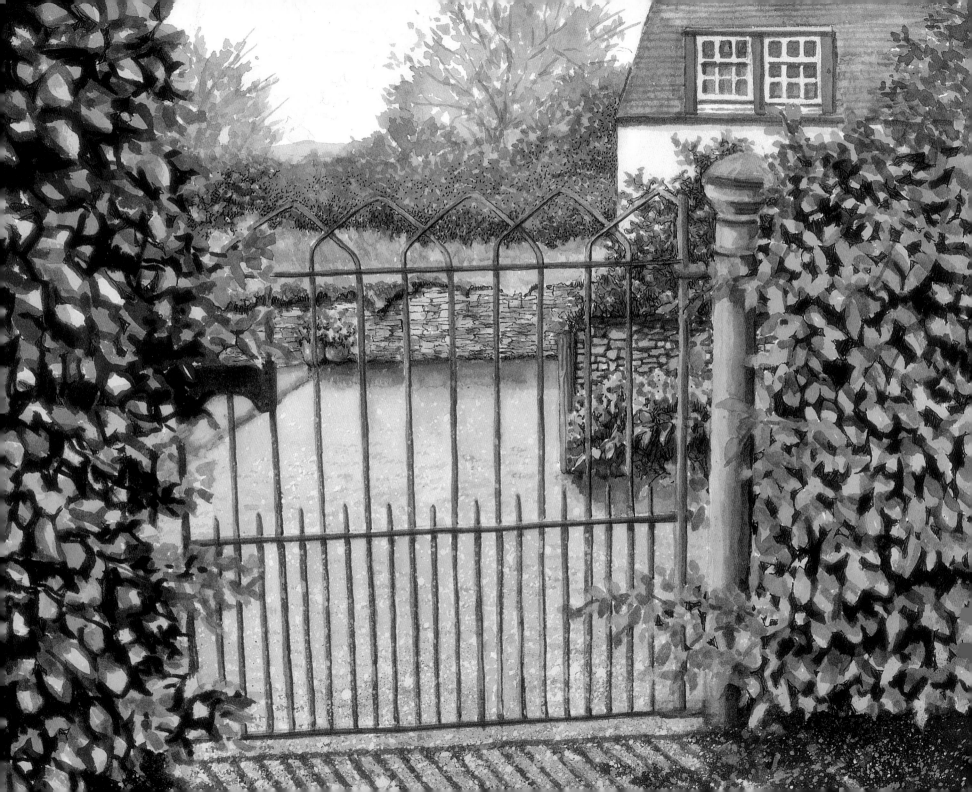

Drawing a Road

Adding a road or pathway to a landscape lends a feeling of depth to the scene, and invites the viewer to visually follow along.

Straight roads move the eye rapidly along their length.

Too direct!

A curved road is less rigid in appearance, inviting the viewer to follow along at a more leisurely pace. However, zigzag roads are a little more difficult to draw.

Breaking the curves into sections can make the zigzags of the road a little easier to visualize perspective-wise. Since this crooked lane was built on level ground, each section corresponds to a different vanishing point on the horizon.

However, curved roads are not usually built on level ground unless there are obstacles to go around. Here is a more realistic view.

Rapidograph pen work - .25 mm

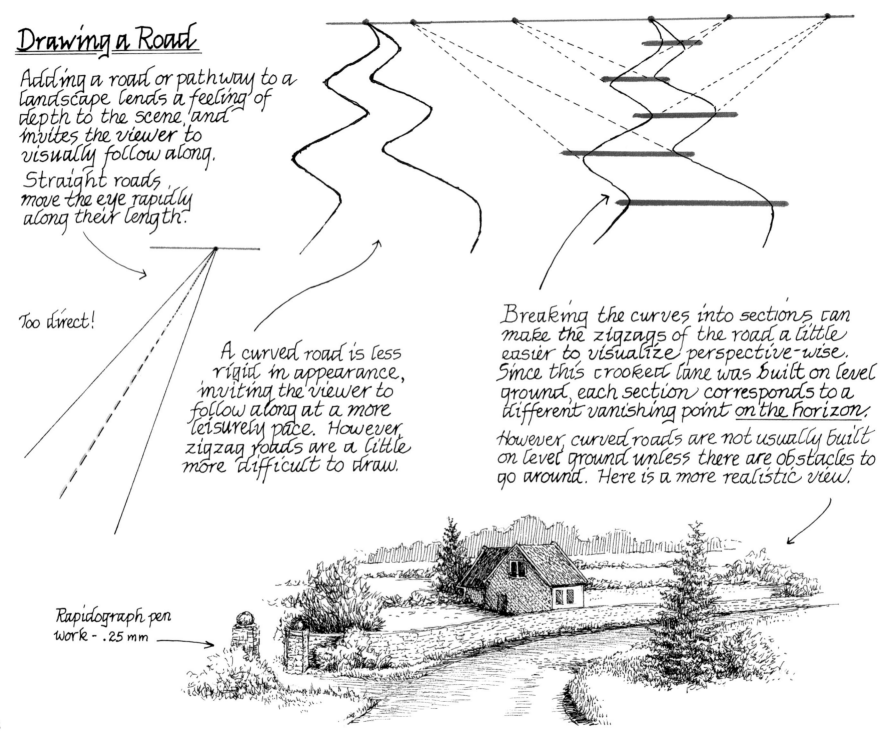

Roads are very effective in suggesting the terrain of a landscape. On hilly ground, part of the road is hidden from view, down in the "dips."

This is the same section of road painted in watercolor. It leads the eye deep into the scene, on a roller coaster path.

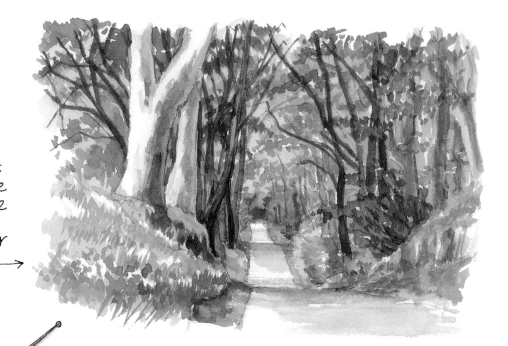

Pen and ink with watercolor wash.

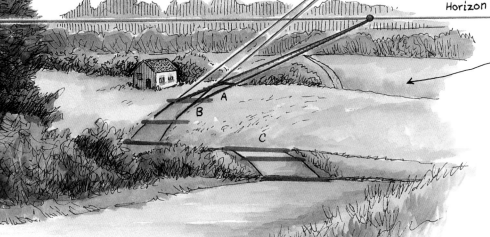

Horizon Line or eye level

A
B
C

Study the road painted in the rolling hills landscape on the left. I have divided the middle sections of the road into segments marked with blue lines. Note that each segment becomes narrowed as it recedes into the distance, and segment A is less wide than segment B and a lot less wide than segment C. Segment A is built on the flat hill crest and its extended lines (red) have their vanishing point on the horizon line. Sections of the road built on an incline like B will have their vanishing points above eye level.

139

Stippling a Dirt Road

An unpaved road has plenty of texture. The road in the painting on the opposite page, entitled WHITMUIR LANE, was in real life constructed of clay and bits of gravel, and strewn with leaf litter. I used stippling to suggest these multi-particle textures in the watercolor rendition.

① A pencil sketch of the receding road.

② Dirt roads can be a variety of tans, browns and grays. I base-coated mine with a mix of Burnt Umber and Dioxazine Purple, thinned to a wash consistency.

Sap Green / Permanent Green mix.

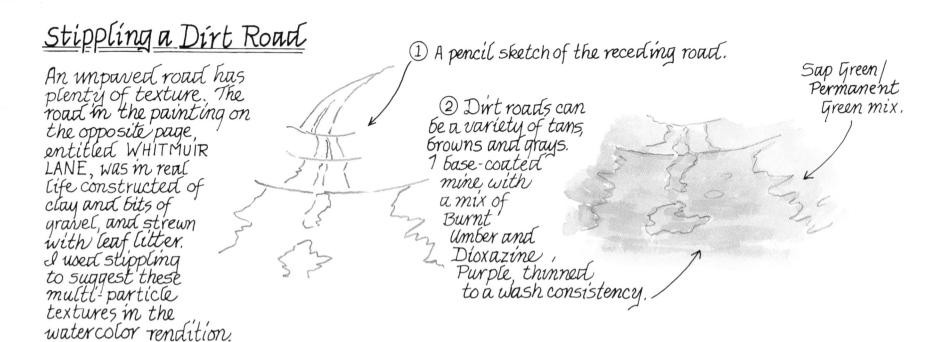

③ Variations of the same color mixes were stippled over the base, using the tip of a no. 4 round detail brush.

④ More purple and Quinacridone Rose were added to the Burnt Umber and the resulting dark tone was brush stippled into the shadows of the road.

⑤ A Burnt Sienna, brush-nibbed, PITT Pen was used to stipple in bits of bright leaf litter.

Brush stippling (horizontal direction)

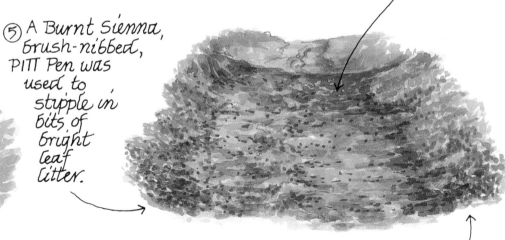

Green, brush-nibbed PITT Pens were used to finish the ground foliage.

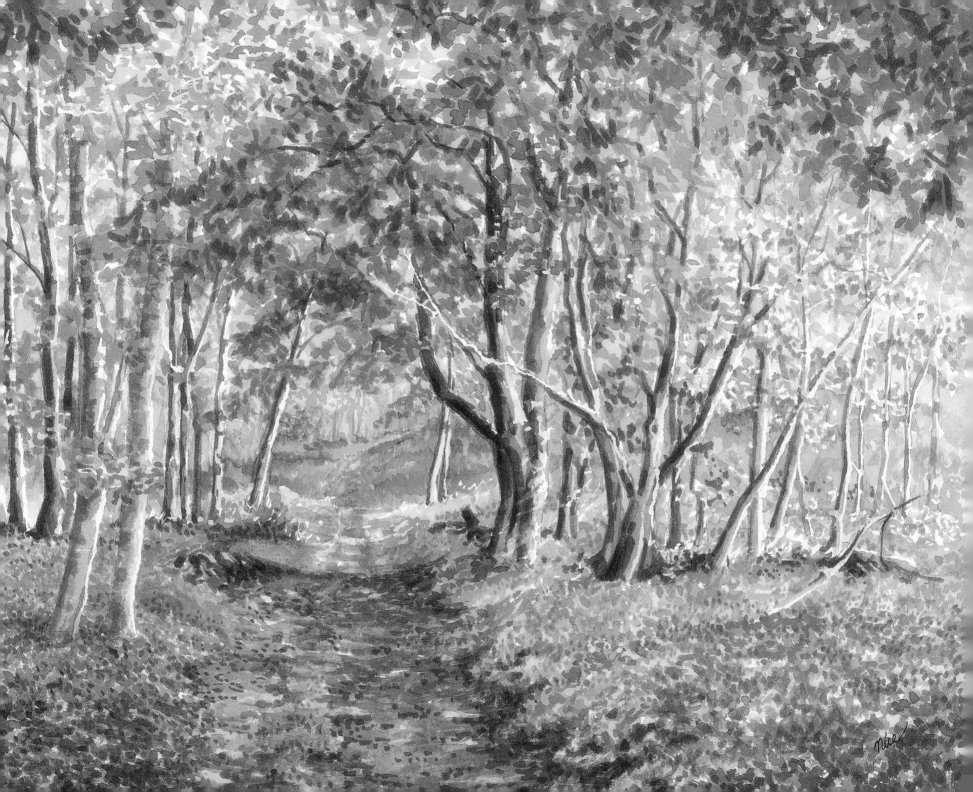

COVERED BRIDGE IN EARLY SPRING
Watercolor with pen and ink.

INDEX

Ideas. Instruction. Inspiration

Receive FREE downloadable bonus materials when you sign up for our free newsletter at artistsnetwork.com/Newsletter_Thanks.

More From Claudia Nice!

These and other fine North Light products are available at your favorite art & craft retailer, bookstore or online supplier. Visit our websites at **artistsnetwork.com** and **artistsnetwork.tv.**

N NORTH LIGHT
BRINGING ART TO LIFE

an artistsnetwork. production

Painting Trees in Watercolor, Pen & Ink with
Claudia Nice

rawing & painting
trees in the **landscape**

more than 70 species of trees

claudia nice | more than **400,000** books sold

Home | News | Books | Enter Your Art | FAQs | Gallery | Register | About the Editor | Shop

Splash: The Best of Watercolor

The *Splash* series showcases the finest watercolor paintings being created today. A new book in the series is published every other year by North Light Books (an imprint of F+W Media) and features nearly 140 paintings by a wide variety of artists from around the world, each with instructive information about how it was achieved — including inspiration, tips and techniques.

Gallery

View Details

Passionate Brushstrokes
Rachel Rubin Wolf

Splash 10 explores "passion" through the work and words of 100 contemporary painters. With each vividly reproduced modern-day masterpiece, insightful firsthand commentary taps into the psyche of the artist to explore where their passion comes ...

View Details

Watercolor Discoveries
Rachel Rubin Wolf

Splash 9 holds its own as a visual showcase, representing some of the best work being done in watercolor today. But of course, that's only the half of it. *Splash* is much more than a pretty face. In the same open, giving spirit that ha...

Get your art in print!

Go to splashwatercolor.com for up-to-date information on all North Light competitions. Email us at **bestofnorthlight@fwmedia.com** to be put on our mailing list!

Follow North Light Books for the latest news, free wallpapers, free demos and chances to win FREE BOOKS!

 Follow us!